MUSEUM PIECES

Finiche! Only a fadograph of a yestern scene.

—James Joyce, *Finnegans Wake*

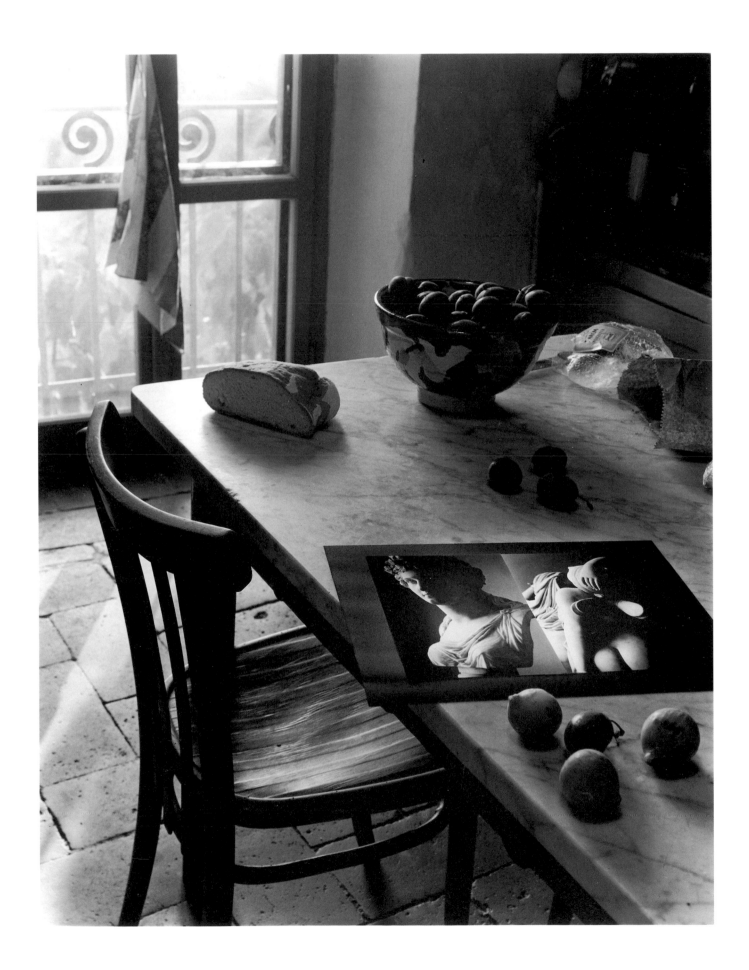

MUSEUM PIECES

Photographs by George Woodman

Essay by Max Kozloff

LO SPECCHIO D'ARTE / NEW YORK

First Edition

ISBN 1-881616-80-0

Designed by Lorraine Ferguson.
Printed and bound by la tipografia editrice Polistampa
in Florence, Italy.

Available through D.A.P. / Distributed Art Publishers
636 Broadway, 12th floor
New York, New York 10012
Tel : (212) 473-5119
Fax : (212) 673-2887

front cover:
CORRIDOR AT CALCI WITH FIGURE Boulder 1992

back cover:
MAIDEN AND SLEEPING FAUN Italy 1994

CONTENTS

DEDICATION

This book is dedicated to the memory of

Francesca,

Friend . . . Daughter . . . Photographer.

ACKNOWLEDGEMENTS

I am especially thankful to:

Susan Kismaric
Curator of Photography, Museum of Modern Art,
for selecting these pictures from the chaos
of my oeuvre and arranging them in the sequence,
articulate and graceful, in which they appear
in this book.

William Bartman
Friend of artists and lover of artists' books,
for his enthusiasm and generosity reflected
in this one.

Betty Woodman
Entelechy of a marriage, for bearing hope like
"Dawn in Golden Sandals".

—*George Woodman*
Antella, Italy, June 1996

Max Kozloff

SHADES OF SCULPTURE

IN THE BRIEF statement he wrote to accompany his pictures in this book, George Woodman speaks circumspectly, giving priority to a technical yet serious question: how to photograph sculpture. Among "sculptors", Rodin and Brancusi were certainly exercised by the challenges of portraying their modeled or carved work in a pictorial record. Rodin, for instance, was obsessed with all those views of real volumes which he had planned for, as an experience in the round, but were necessarily averted at any one time from the stationery gaze of the camera. Brancusi, also, was concerned with how not to libel too much, the presence, scale, and design of his work when reduced to photographic tones. Both sculptors saw in photography an interpretive but servant-like adjunct to their 3-D vision. However, for Woodman, a painter throughout much of his career, photography since 1989 has been the medium of choice, and his subject is *other* artists' sculpture, with whose appearance he does not hesitate to take liberties.

Though he obviously respects his motifs and fancies them, Woodman's images of sculpture are just as evidently atmospheric, not descriptive. In his art, many solid objects have only a distant and dubious existence as tangible forms. For all that we may feel close to them in space, we are several steps shy of them, optically. In fact, the nude figures from Mediterranean antiquity or the Renaissance, as well as later classicizing styles, framed by Woodman, are often perceived as shades that obscure each other. One really has to delve through tones that are sometimes inverted by negative printing to make out these sculpted nymphs and deities. As the complexion of old things can sometimes be discolored, these new photographs are "distoned." Then, too, multiple exposures and superimpositions keep the precise shape of many sculptures indistinct. Rhythmic and approximate echos of them, rather than exact contours, tell us they are voluptuous.

Further, as treated here, the sculptures are occasionally juxtaposed with paintings of like subject or seen only as depicted in photographs among still lifes or in rooms, to disconcerting effect. Into such montage structure, Woodman introduces the ghostly inprints of flowers, with curved stems, half eaten figs and other fruits. The undulent searching of the stone draperies and the tendrils of real plants are made to rhyme with each other in the same space. This melange of appetite and memory evokes visits to museums, luncheons on the grass, regrets, the mingled sense of which could only have been fashioned in a dark room. A legacy—the Hellenic past—is figured in general terms, whose tact fails to conceal the personal significance it has for the artist as he remembers and alludes to it. George Woodman and his wife Betty have been living for thirty summers and more in Tuscany. This art is like a pictorial arboretum of all those impulses and meanings that drew them there. And yet one thing the artist leaves unmentioned in his statement "Notes on Sculpture and Photography" is the appearance in a number of his images of two real, naked, young women, with Asiatic features.

They can be called, by rights, "the models", for modelling is their nominal role in Woodman's imagery. A model (a figure) is not to be confused with a sitter (a person), whom we discover in portraits. The former is a lowly though still dignified creature, "there" only as the mute source of an appearance formed in the training of the eye and the hand of an artist. In that exercise, considerations of her feelings and character are not to the point. But in the context of Woodman's photographic art, the fact that she looks back and has her own thoughts distinguishes her from all the stony effigies with which she's juxtaposed. In KIM IN THE MIRROR, (p.65), there even plays over her features what the psychologist Erving Goffman called "a knowing smile." Sentient and reactive, the model has an advantage over the idealized and immobile versions of her own kind. Woodman overcame, in this case, the discomfort he has said he often feels in pointing a camera at someone. On one level, he has reduced the psychological and maybe moral issue of photographing a human being to that of a sculpture. But on another level, by virtue of the model's cameo role in their world, he has insinuated an animism into sculptures beyond that suggested by their makers. For an artist who enjoys reading the wondrous if sometimes cruel descriptions in Ovid's *Metamorphoses,* this was a natural outcome.

Among the myths that are told there, Woodman allows that two in particular have interested him. One is the story of Orpheus, a singer and musician, whose young wife Eurydice dies from a serpent's bite. He resolves to descend into the netherworld, before whose king and queen

he pleads for his beloved's return. "She will come back again as your subject after the ripeness of her years. I am asking a loan and not a gift." Moved by the beauty of his song, they grant him his wish, provided that he never look back upon her as he guides her to the world above. But as they climb, at one point he forgets (or disobeys?) and she is lost.

The other tale tells of Apollo and Daphne. The boy Cupid had been disparaged by Apollo. In revenge, he shoots the god with a gold headed, love igniting arrow, and likewise the nymph Daphne with a lead tipped arrow, which infuses her with repulsion at the desire of men. She vows her chastity to her father, the river god Peneus. When Apollo catches sight of Daphne, he gives immediate chase. He thrills to her loose hair, flung over her shoulders, but thinks that "If so charming in disorder, what would it be if arranged?" At length, weakened, overtaken, and about to be ravished by Apollo, Daphne calls out to her father to open the earth to envelop her or to change her form. And at that instant, her torso is encased in bark, her fingers and hair are transformed into branches and leaves, her legs and feet become roots. The god is left with a laurel tree, whose foliage he will fashion into his crown, and whose image he will use to decorate his harp and his quiver.

These stories tell of women who, at the very moment they are about to be won, are irrevocably denied to, the men who love them. The climactic loss is, of course, related entirely from a male point of view. Henceforward, the women will live on only as memories, celebrated in art. A bond that cannot be attained in life is recreated and honored in the imagination. George Woodman's treatment of sculpture resonates of this process, encoded into the references with which he deals. When they were venerated as deities, the statues of women were enthroned in temples; later, they were placed in museums. Across this secular distance, where they are ensconced within what he has always considered real places, the artist revisits these icons, kindled by their archaic trace of divinity. As a result, for all that he is a modern in technique and outlook, Woodman has no trouble calling this book "Museum Pieces."

However, a past eroded by time and recovered in the present is only one among a number of his themes. He speaks of the "sadness" of sculpture [of whatever epoch] which "may lie in the painful restriction of creating a *substitute* reality as oppposed to *picturing* reality . . . the sculptures at Versailles have a charm in Atget's photographs which they do not have in actuality. Like fashion models, their beauty as pictured makes us forget their exposed homeliness in reality." Even when projected as an ideal form, the physical presence of a sculpture is always literal and a bit raw;

it lacks the metaphoric range of the pictorial. Here, the thought echoes a far earlier one in Leonardo's comparison of the arts: "Sculpture reveals what it is with little effort; painting seems a thing miraculous, making things intangible appear tangible, presenting in relief things which are flat, in distance things near at hand."

The "miraculous" is an effect of a pictorial activity which holds objects in sight, yet transmutes them. Woodman visualizes that effect, not through the marks and the matter applied by a painter, but by the immaterial tones that emerge in a photograph. And he accepts very well that "charm" might even require him to do violence to the transcriptual bias of photography. Except that they quite frankly *reveal* their darkroom origins, his doubletakes resemble a little those in 19th century "spirit" photography. The spirits of the departed are captured through the magic of multiple exposures. An unmistakably funereal mood runs through a few of Woodman's pictures, not least those that show statues of mourning women at close quarters. Look at the picture he titles NORWEGIAN APHRODITE (p.35), which recalls the Daphne legend, or MAIDEN AND SLEEPING FAUN (p.44). It would be fair to say that he is preoccupied with the death and the rebirth of their allusions in the etherealized shades of his art.

The frames (of photos or paintings) within the overall frame of his picture act as a means to structure Woodman's bracketing of representations, to stand clear of them, as if in a separate mental space. We're left in no doubt, for instance, that Hellenic sculpture is a subject of his work, not an influence upon his style. In that regard, Robert Rauschenberg has affected him far more than Praxiteles. Just the same, a viewer is struck by the way these "museum pieces" mix a psychic distancing and an involvement with their motifs in a kind of emotional depth that may be fathomed. With that impression in mind, let's return from the perspective of the old stories themselves, to the way he looks at his subjects.

The Apollonian gaze is traditionally possessive and controlling. It prizes order, clarity, and airless light, which not only distinguish one thing from another, but isolate all phenomena. The rationality with which it pictures them may be passionate but it is also cold. We remember that in his general attraction to the fleeing Daphne, Apollo was especially pointed by the thought of her hair neatly coiffed. With their precise contours, uniform, dry shading, and pastel colors, tastefully adjusted, Woodman's paintings of nymphs from the 1980s expressed a kind of tentative Apollonianism. Closing with his actual sources in black and white photographs that are painterly, the artist visualizes a duskier, more empathic world. Lines of sight are deflected in passages that

are sometimes competitive and overlapped with each other in tenebrous zones. Unquestionably he retains a certain formality, even symmetry, in the disposition of things. After all, most of his images address us as displays, appropriate to the genre of still life. Yet, the suavity of display is mingled with a kind of filmic turmoil.

The former suggests the self-confidence of a viewer who relates to detached objects. The latter implies the unrest of one who perceives his or her own share in a drama that turns the old legends into markers whose narrative hints of frozen sex ricochet among images of furnishings — tables, doorsteps, windows — irradiated from the artist's own life. Here, we reckon with a warmer, apparitional environment. But if we seem able to breathe its air, we also take in the disturbance that it evokes.

Woodman's sympathies as a picture maker run parallel with the split-second and multi-form reversals in Ovid's poem. The decorous and emblematic elements in his photography act as titles do in a silent film. While they interrupt the flow, they also articulate the course of events. The literary import of these quotes from the antique is nevertheless contained or immersed in a solvent of shifting, purely visual, unnatural light. It suggests metamorphoses that one can't quite catch, or that occur "off screen." A body is in two places at once, or causes uncertainty about it's being anywhere at all, other than in the mind. Time itself is distended, in the artist's diaristic flashbacks or flashforwards. Such paradoxes hint of the supernatural, though they are only attributes of his program. The program establishes a general interest, but does not in itself have a poetic value. It's just that Woodman's program fosters discoveries — of association — that could not have been realized by other means.

Consider BACK WITH CARVED PANEL (p.58). It's one thing to say that a wooden panel with floral relief is superimposed, or seen through, the model's naked back. It's quite another to perceive an effect that makes it appear as if her flesh has been *scarred* by a most elaborate and tender design. What had started out as an "idea", in this mating of two images, concludes as a startling vision which may not have been anticipated. The two hands — sculpted or real? — that appear to present the panel (or grip the model) contribute a further, sensual touch to this already erotic fantasy. Psychoanalysis has a word of Greek origin that describes such a process: cathexis — the charge of psychic energy invested in an activity, object, or idea.

We know that Woodman's procedures involve him with laminating and rephotographing images. Actually, he filters the sentiments they infer in overlays that reflect his cultural per-

spective. While this covering-up may be an approach familiar in art from the nineteenth century, the sense in his work of a tearing away connotes an anxiety of the twentieth. Among many images that oscillate between these two views, LADY WITH A HANDKERCHIEF (p.70) produces a shiver. It has the feel of a Victorian fashion plate or exhibit in a wax museum that has gone wrong in a harsh luminism. "Wrong", in this instance, means coming alive. A dainty, gloved hand, about to drop a hanky, and a smiling mouth from a chopped off face add a note of sinister coquetry to this ancient Venus. But the spangled dress pulled back from the torso gives her nakedness an uncanny presence, as if it were indeed the picture of a "her" we see, not an "it."

Surrealism is the only modernist idiom to enjoy an afterlife, of sorts, among our post-modernist styles. These "museum pieces" belong to the post-modern mode, with a surrealist over-tone. Though quite brutal, Cindy Sherman's old master mockups are perhaps their distant cousins. Very well. But if one inquires as to artists with whose work George Woodman has a greater affinity, none is closer than his daughter, Francesca.

She was raised by her parents in Italy, and when she, too, became an artist at an early age, she took to the camera with relish. Before the lens, she posed, or rather, performed in what look like self-portraits as well as nude studies, but are more likely allegories about her own consciousness. They depict a fragile girl-child in desolate, mouldering rooms, who either flutters in their space or melds with their surfaces, courtesy of long shutter exposures. The youth of the artist stands in contrast to the precocious melancholy of her dream. Conch shells, eels, and opened melons are used as classic symbols of her desires . . . and alarms. In one image, she holds a filleted fish spine upon her naked back. Clad in a chiton, she fantasizes herself as a statue in a Greek temple, fixed in place for the ages. Her father's art, in his later season, continues and enlarges upon much of this subject matter, with a curious buoyancy that runs through both their images. As she searches into questions of identity and fate, while he engages with the culture that defined them, it's obvious that both maneuver in the same imaginative world. How plain it is to see, now, that for him the issue of photographing sculpture was never just technical. Francesca Woodman died, a suicide in 1981, aged 22. Instead of a child who inherits the work of an artist parent, this time it's the other way around. The fact lends poignance to the retrospective glance of Woodman's "museum pieces". They seem bent on returning to some point in the dominion of feeling they can never reach, a motion that imbues so many of his works with the character of a lament.

MUSEUM PIECES

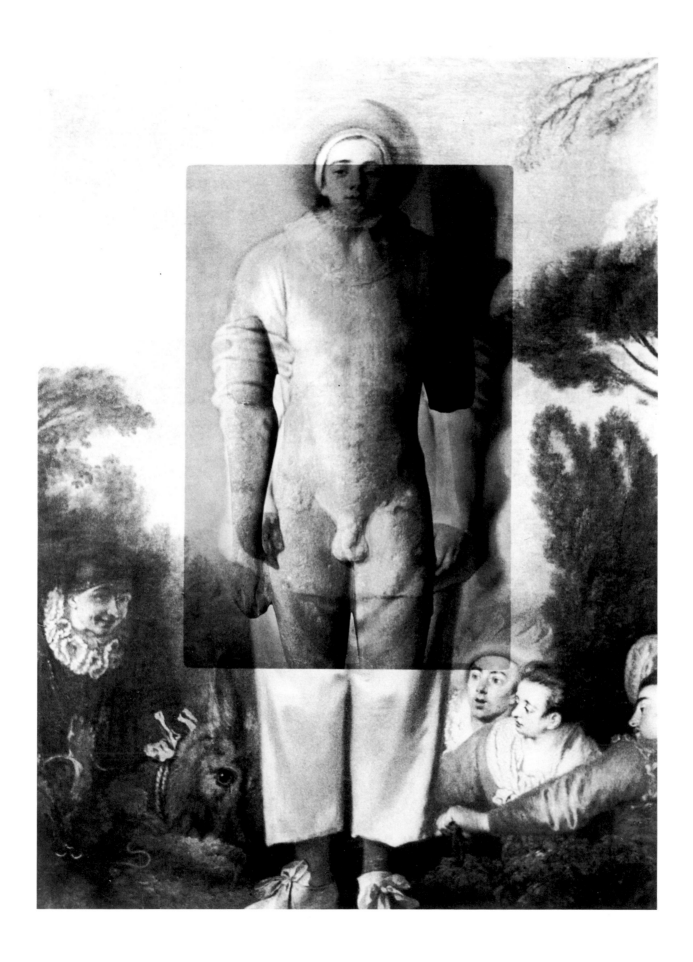

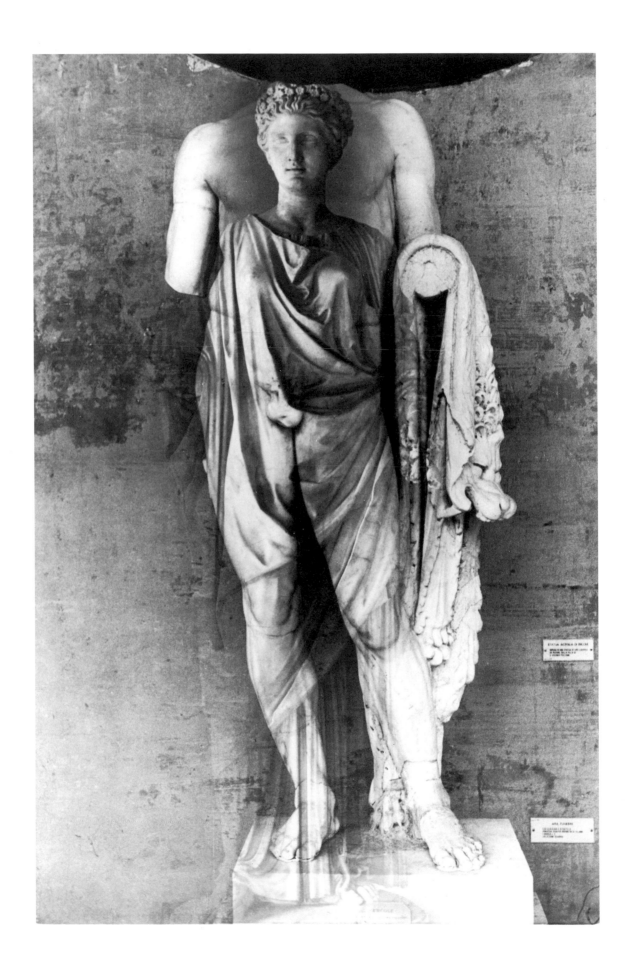

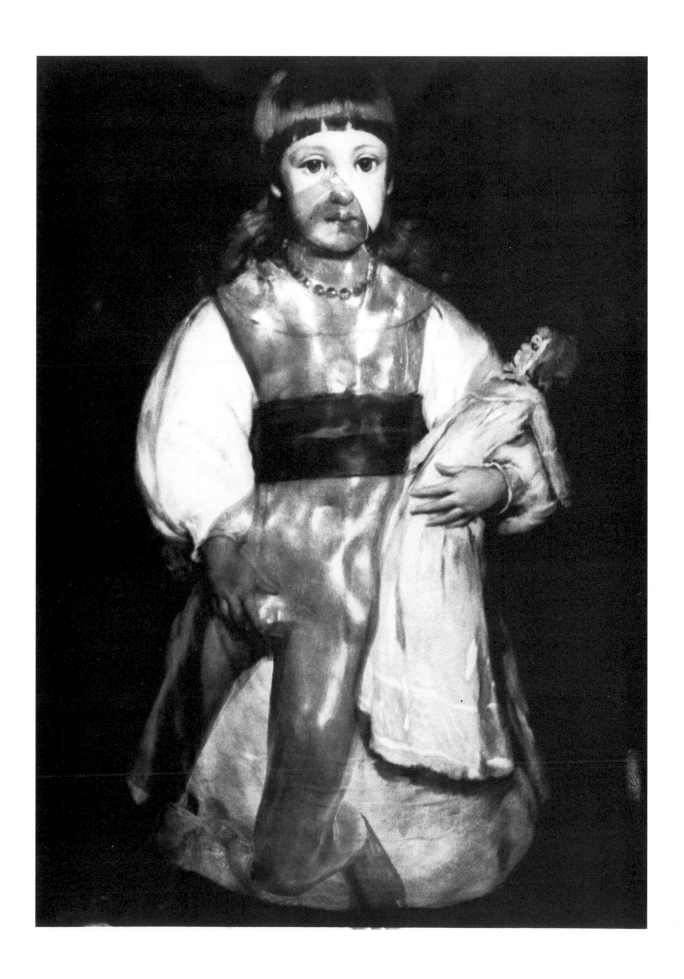

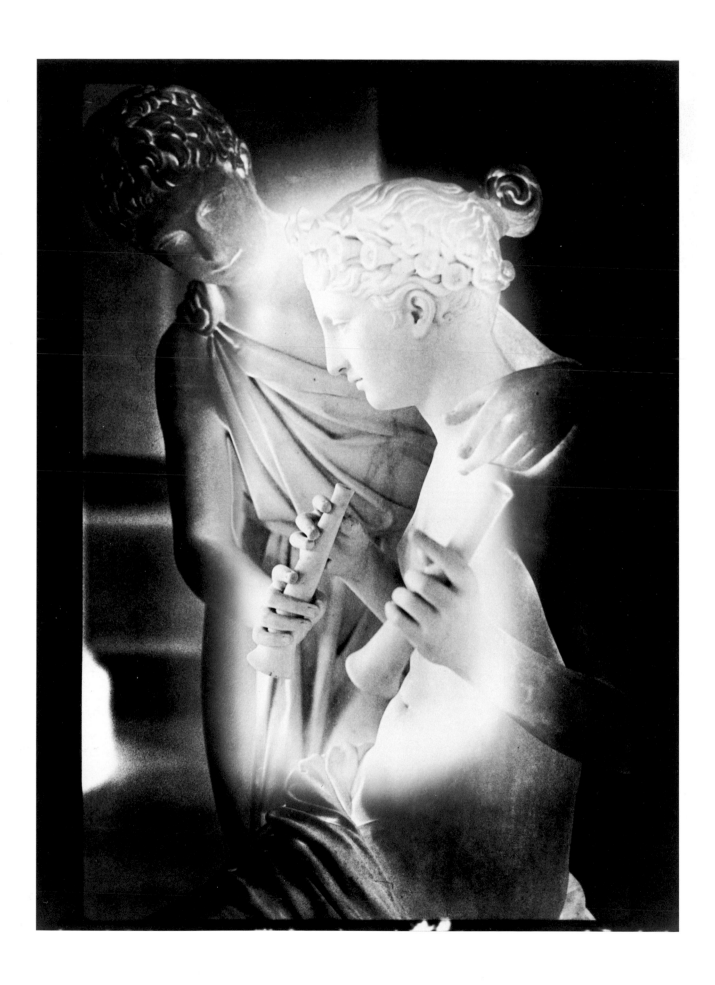

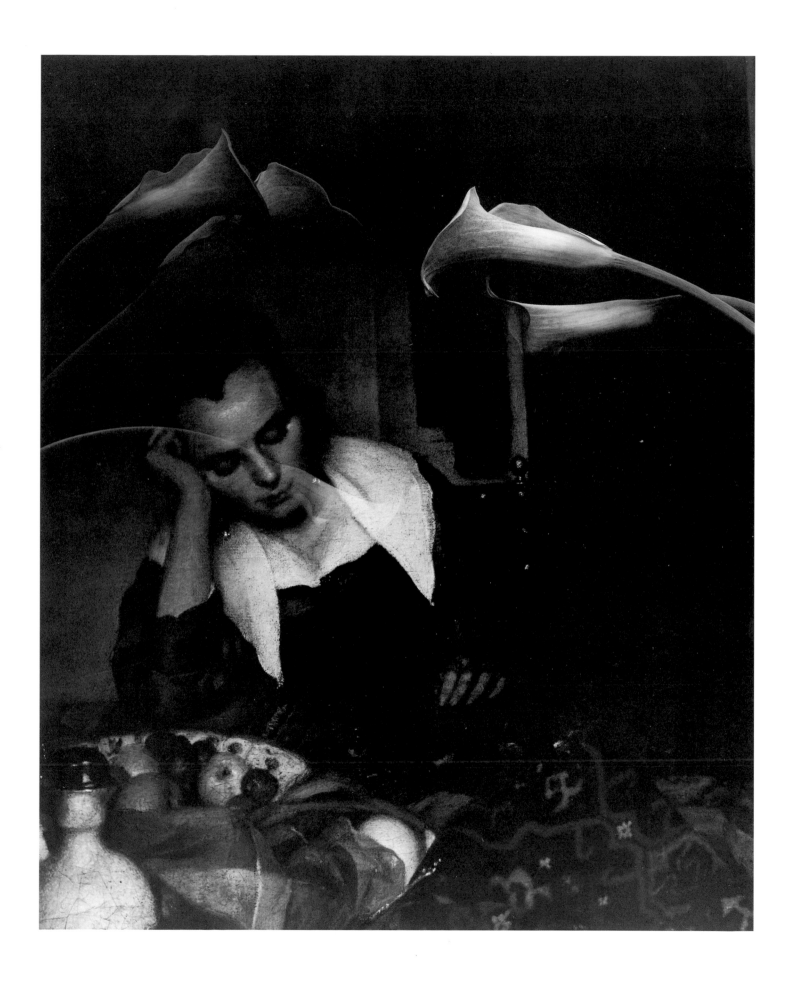

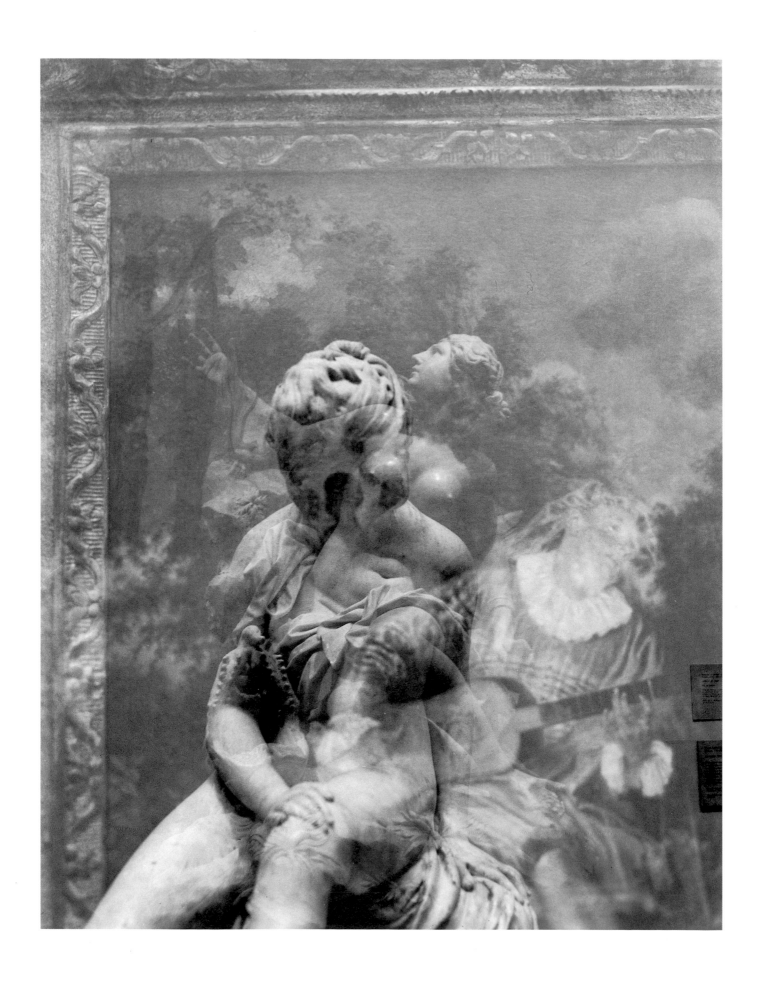

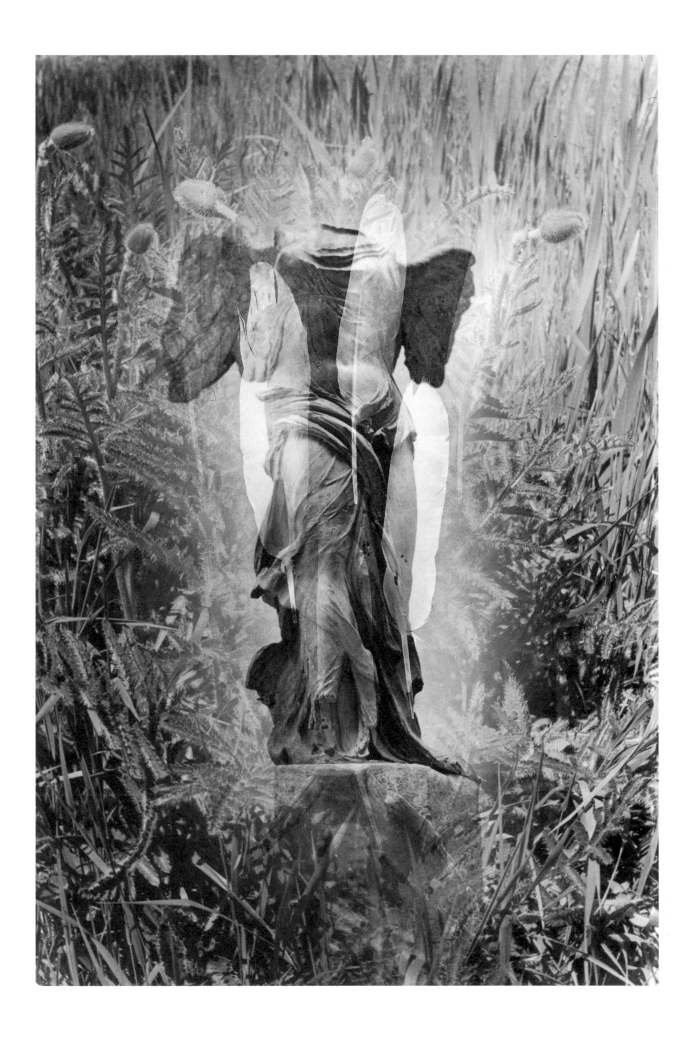

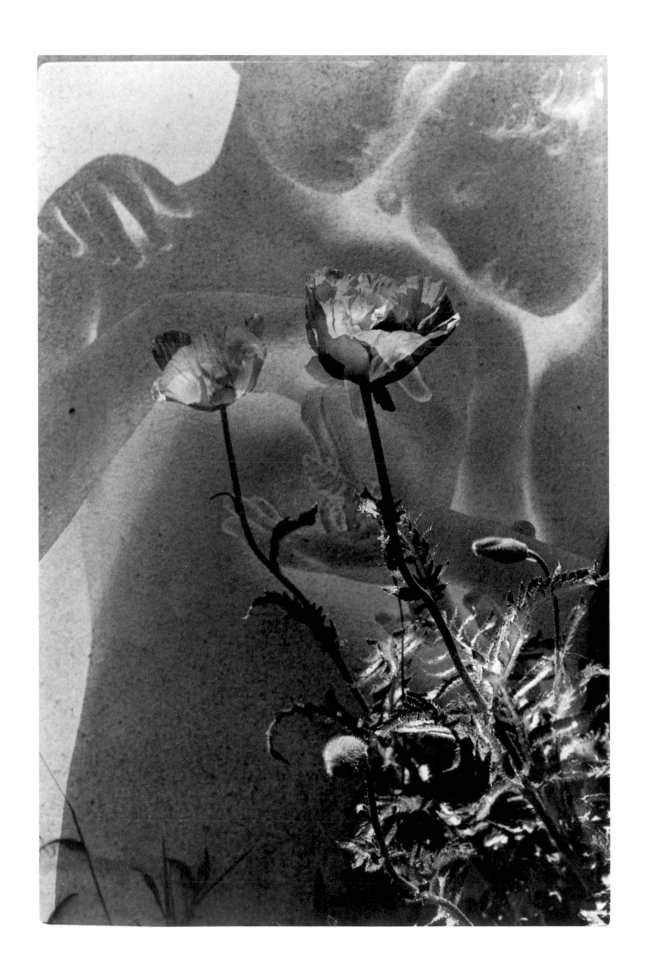

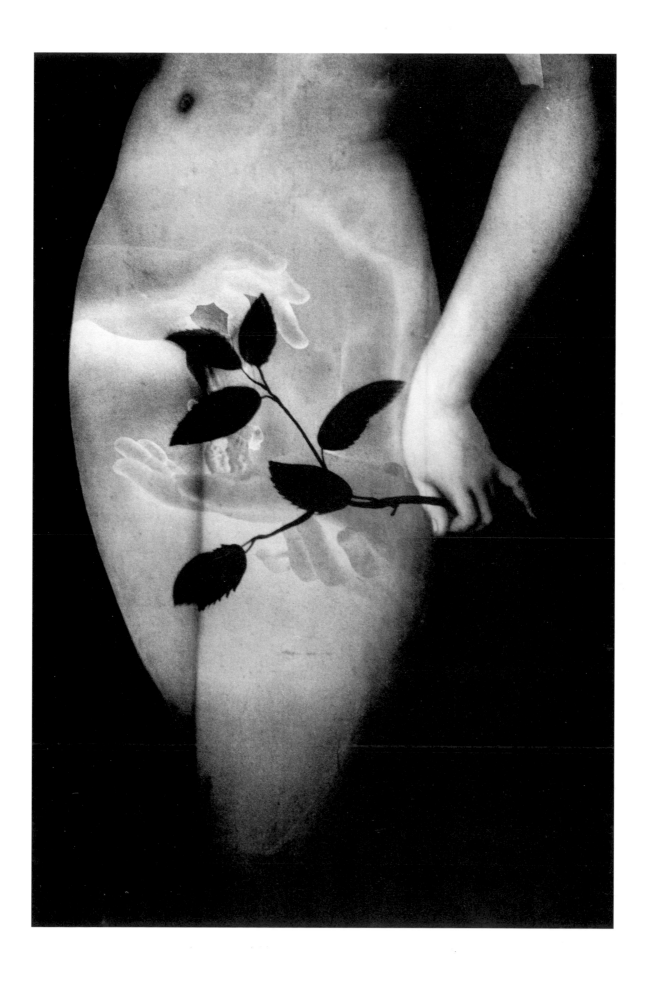

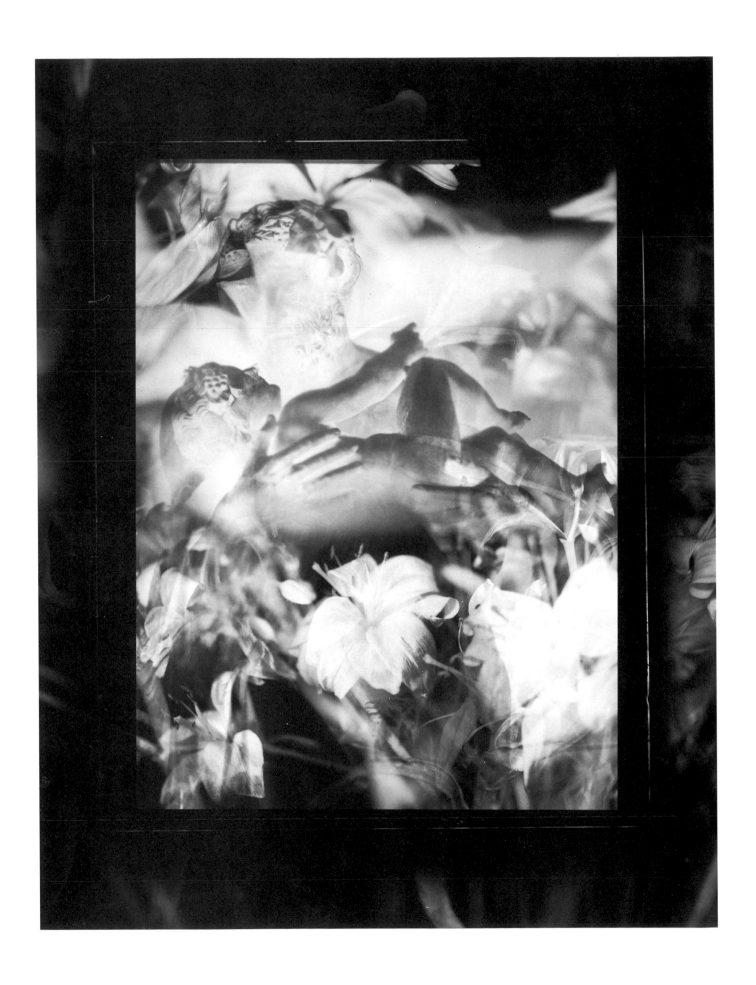

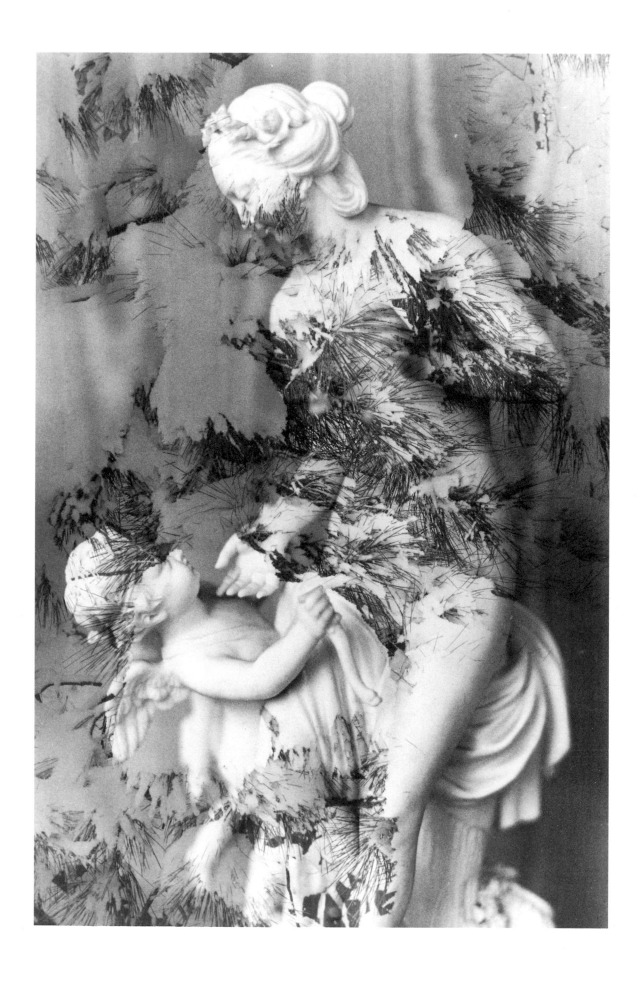

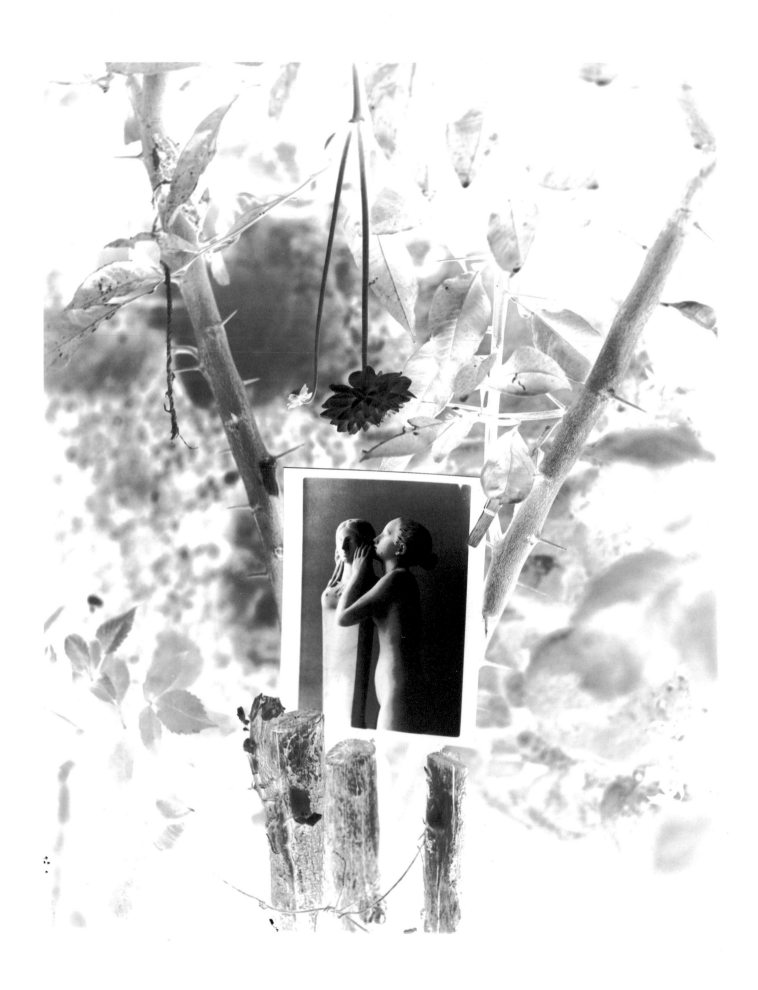

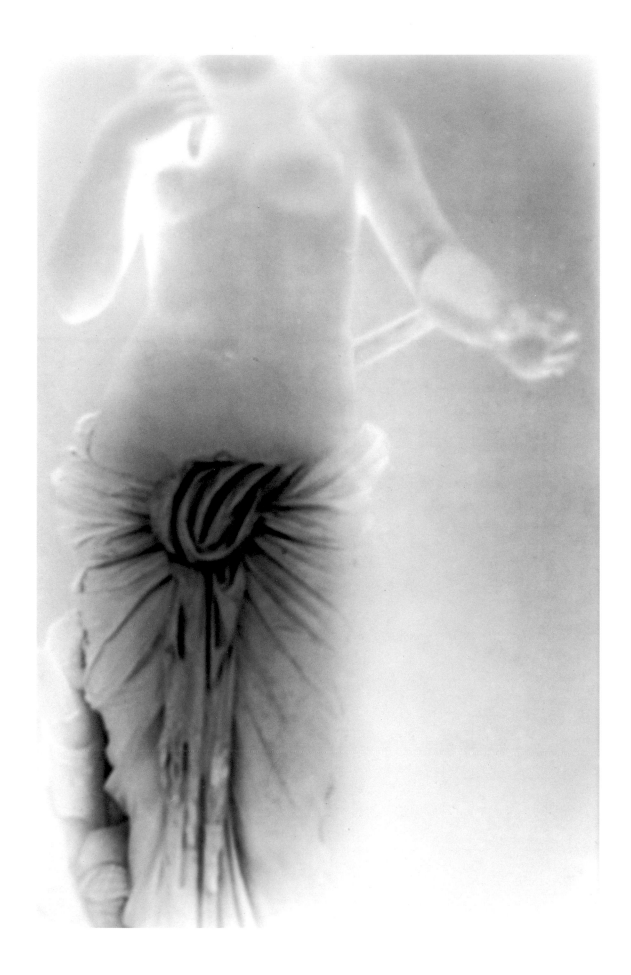

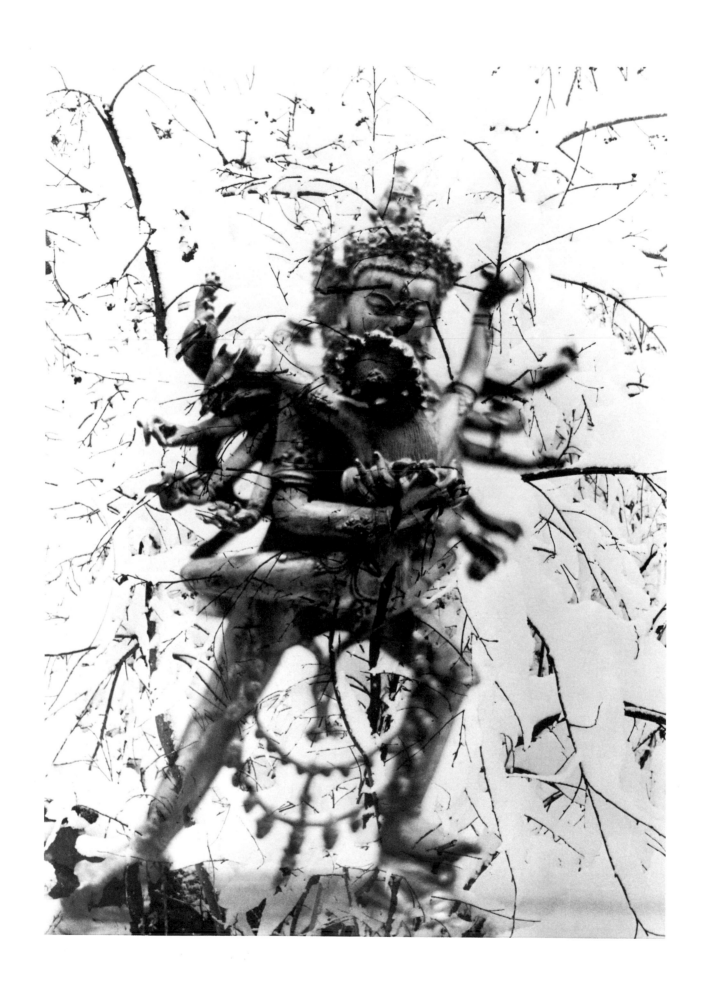

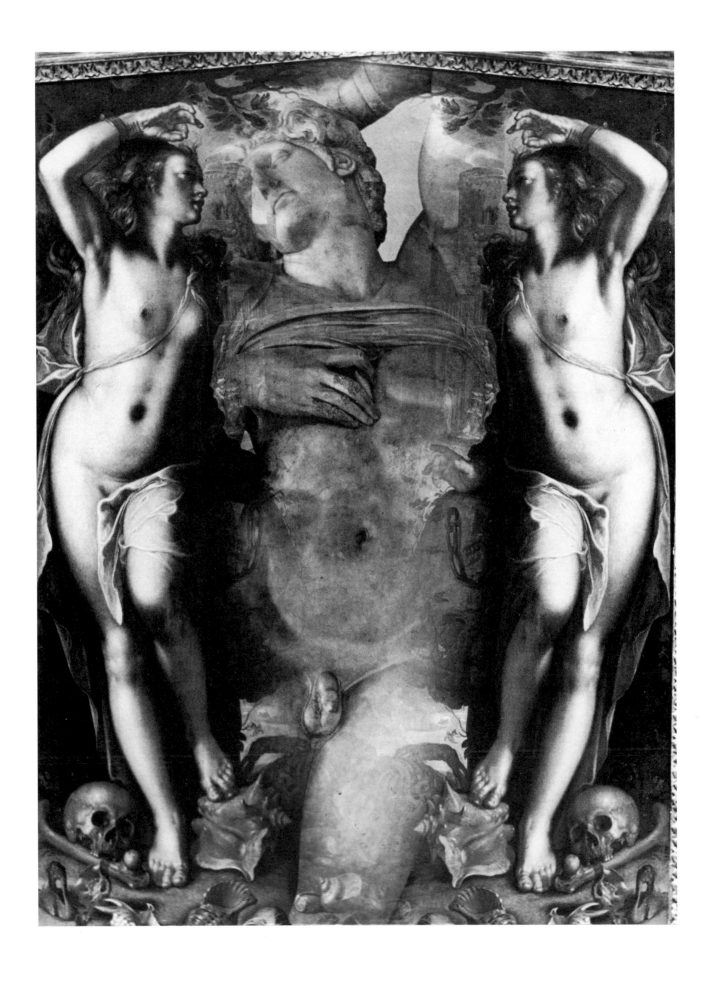

31

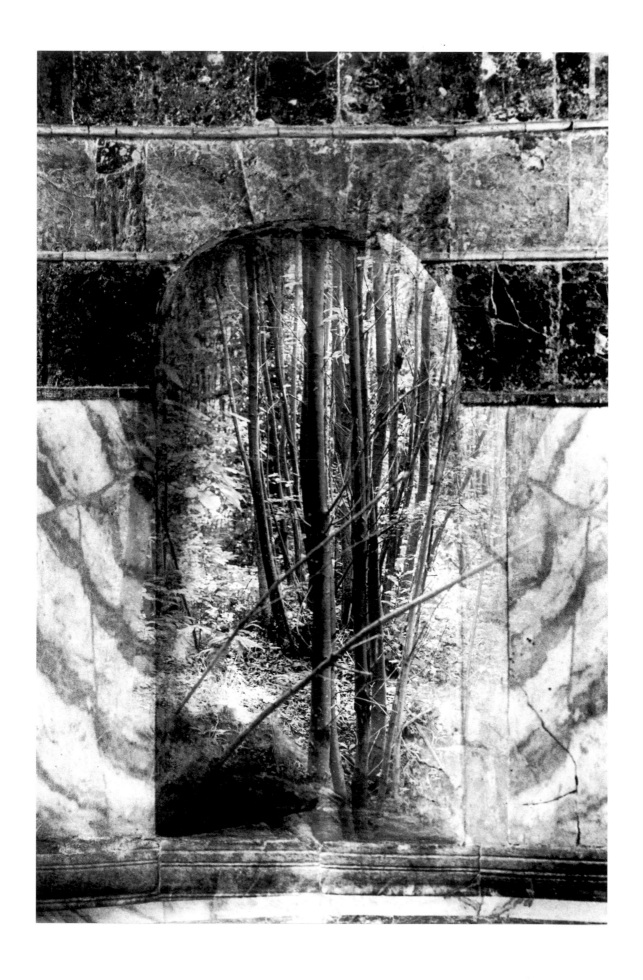

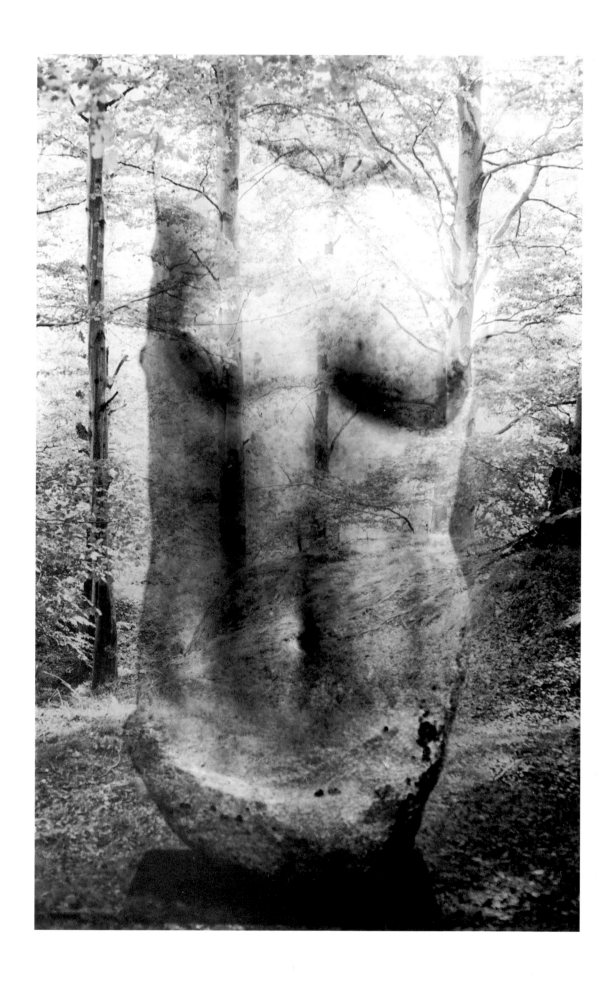

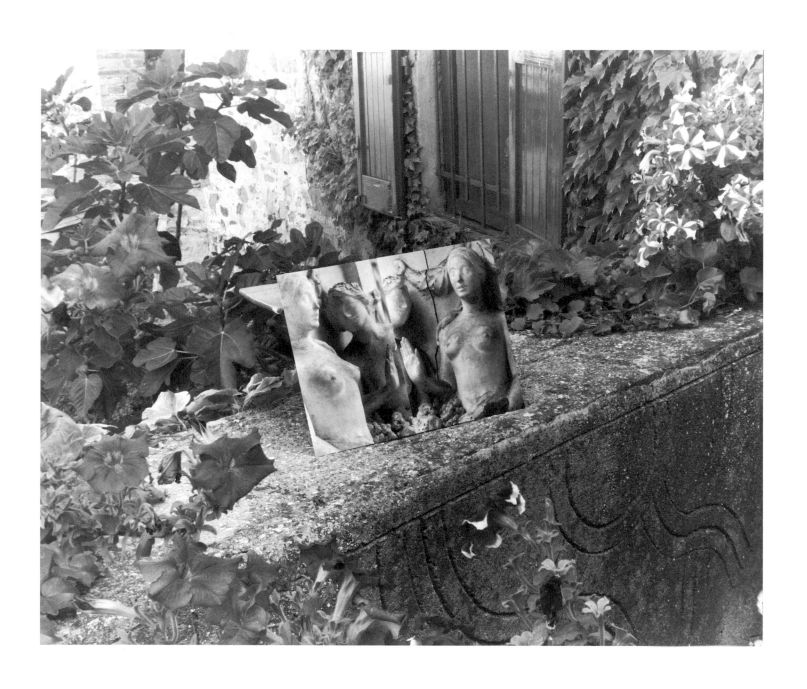

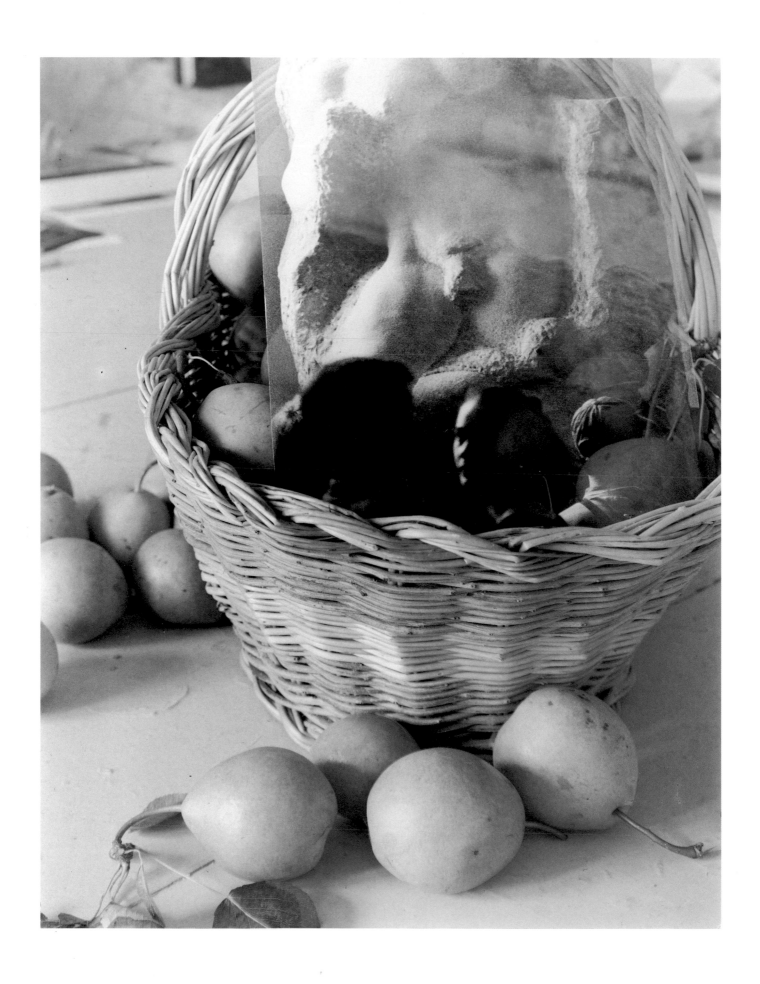

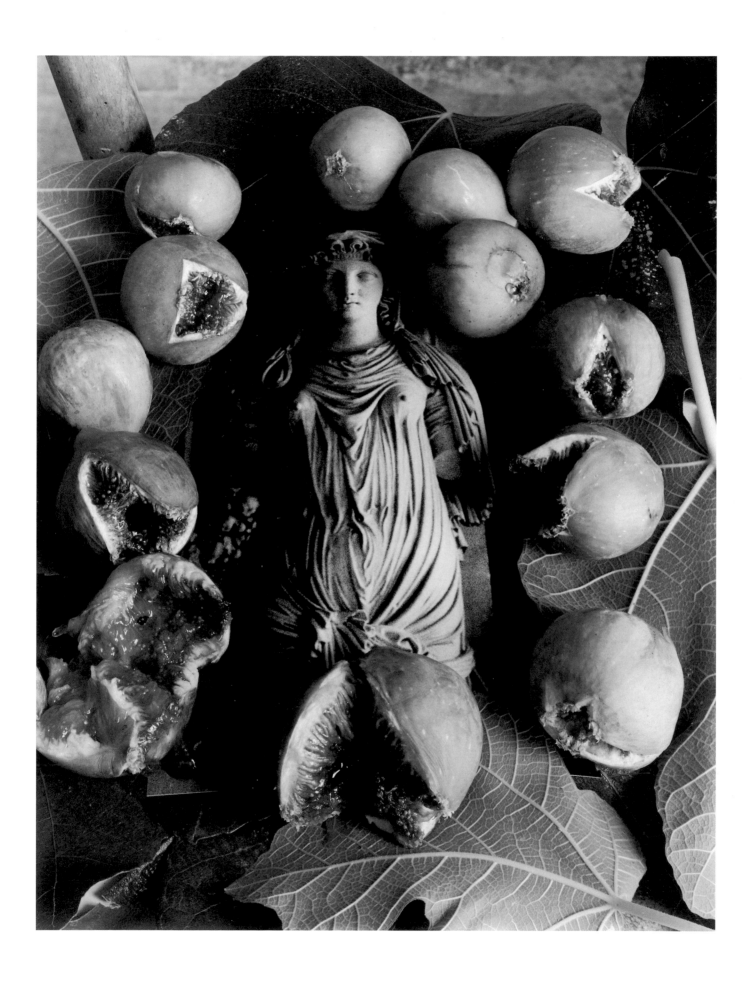

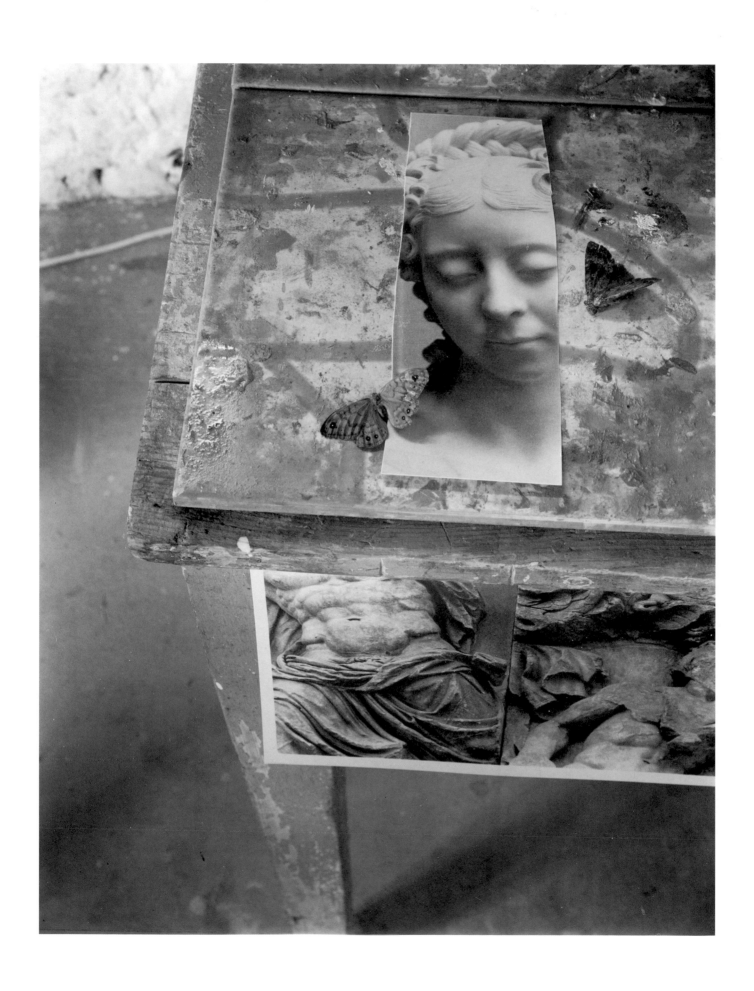

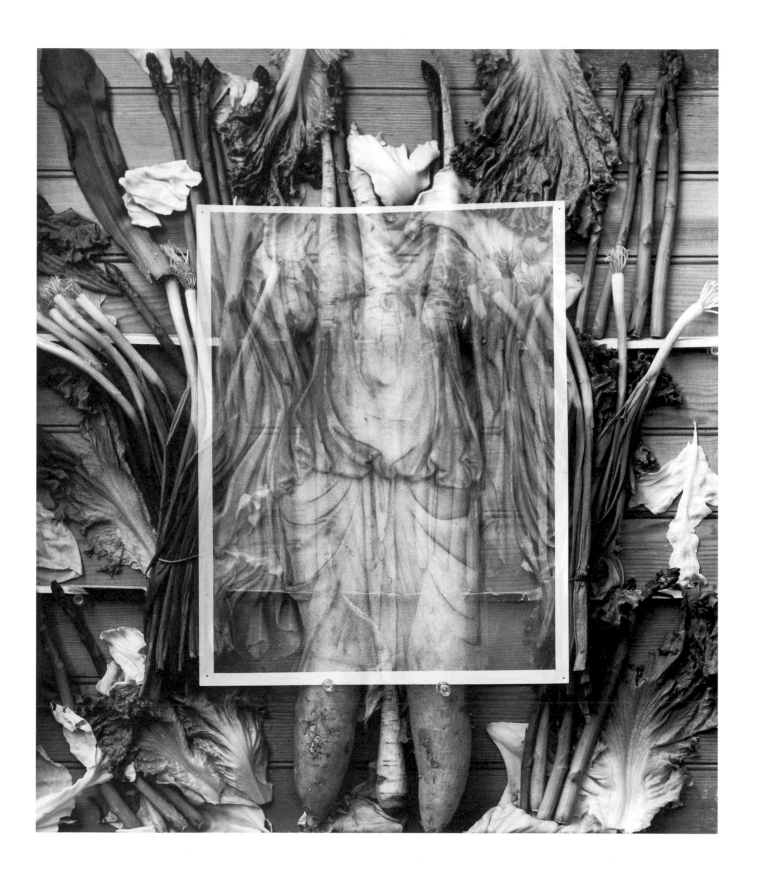

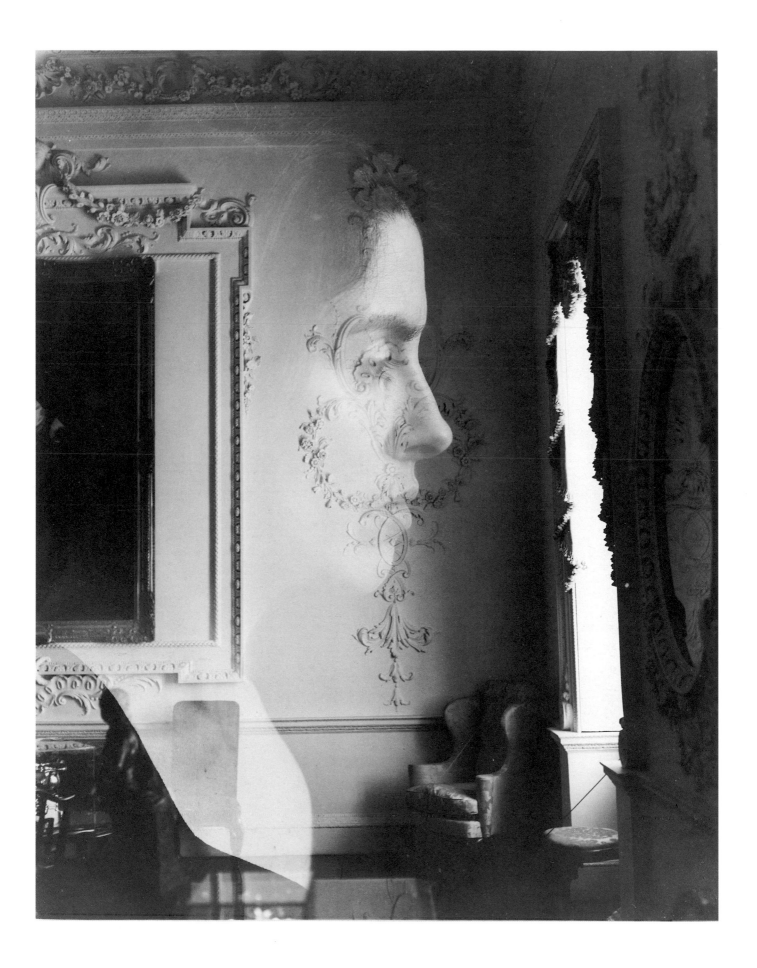

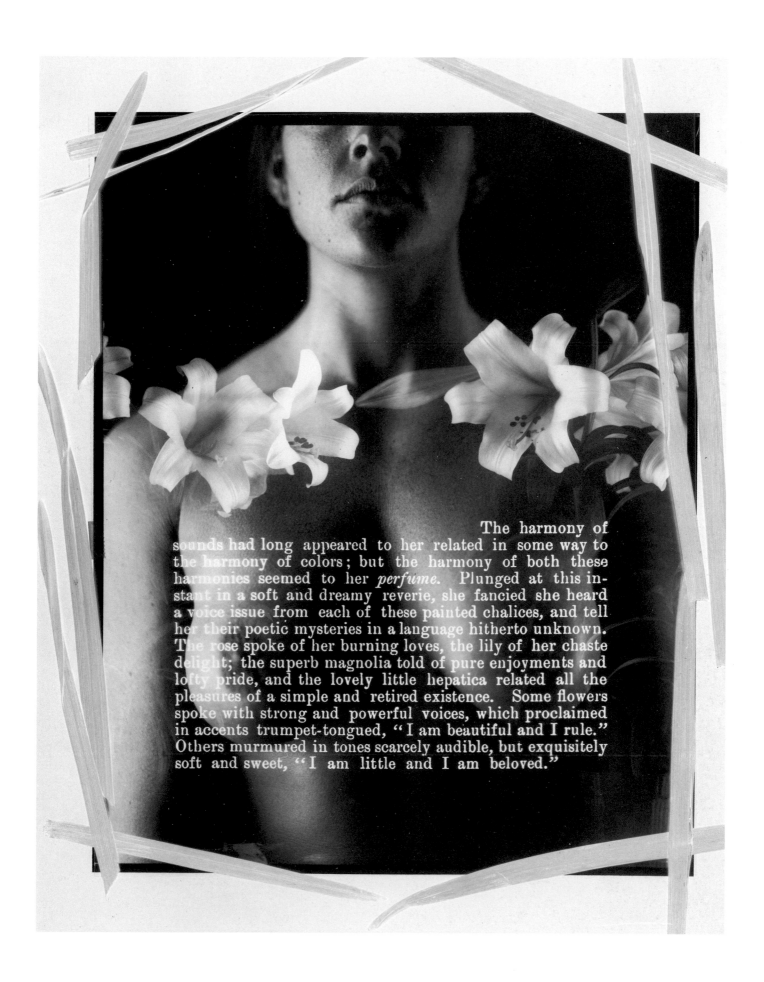

The harmony of sounds had long appeared to her related in some way to the harmony of colors; but the harmony of both these harmonies seemed to her *perfume*. Plunged at this instant in a soft and dreamy reverie, she fancied she heard a voice issue from each of these painted chalices, and tell her their poetic mysteries in a language hitherto unknown. The rose spoke of her burning loves, the lily of her chaste delight; the superb magnolia told of pure enjoyments and lofty pride, and the lovely little hepatica related all the pleasures of a simple and retired existence. Some flowers spoke with strong and powerful voices, which proclaimed in accents trumpet-tongued, "I am beautiful and I rule." Others murmured in tones scarcely audible, but exquisitely soft and sweet, "I am little and I am beloved."

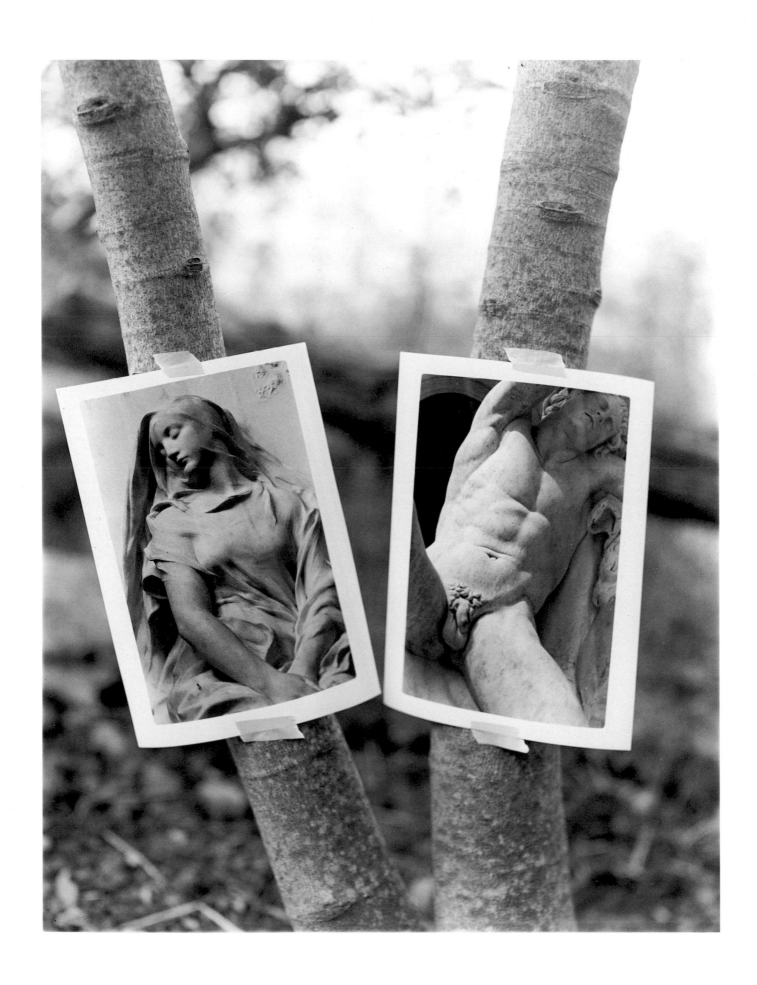

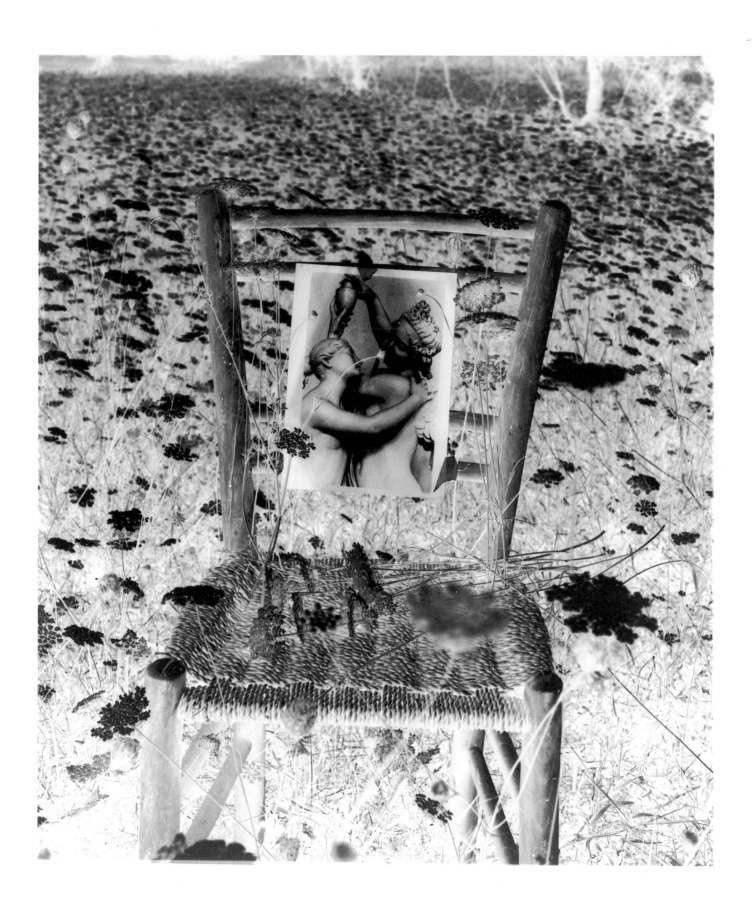

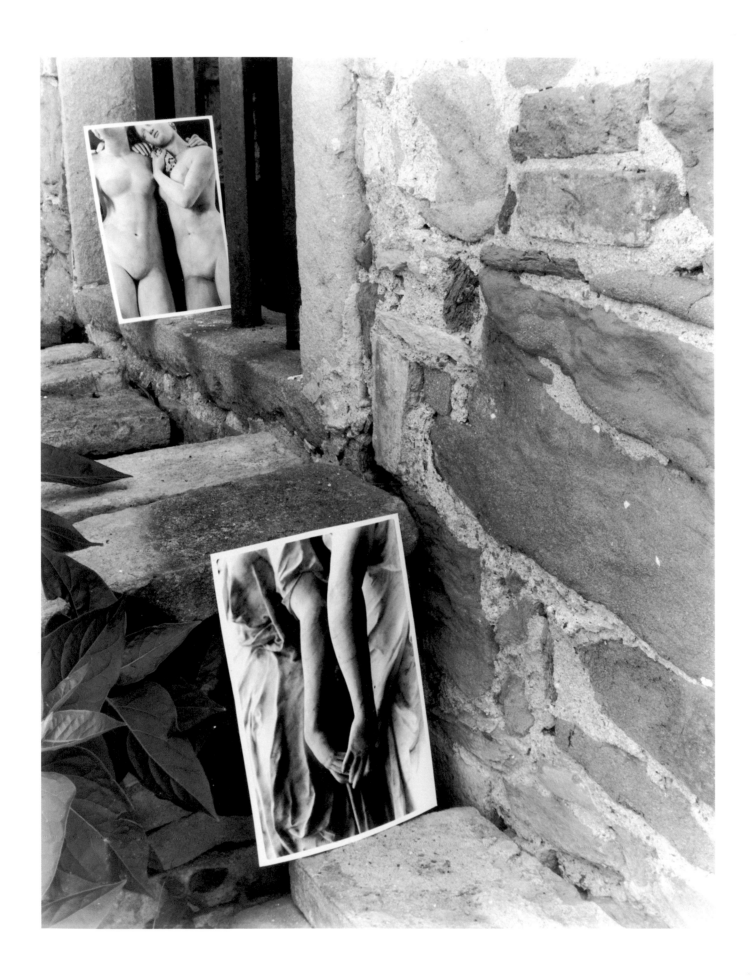

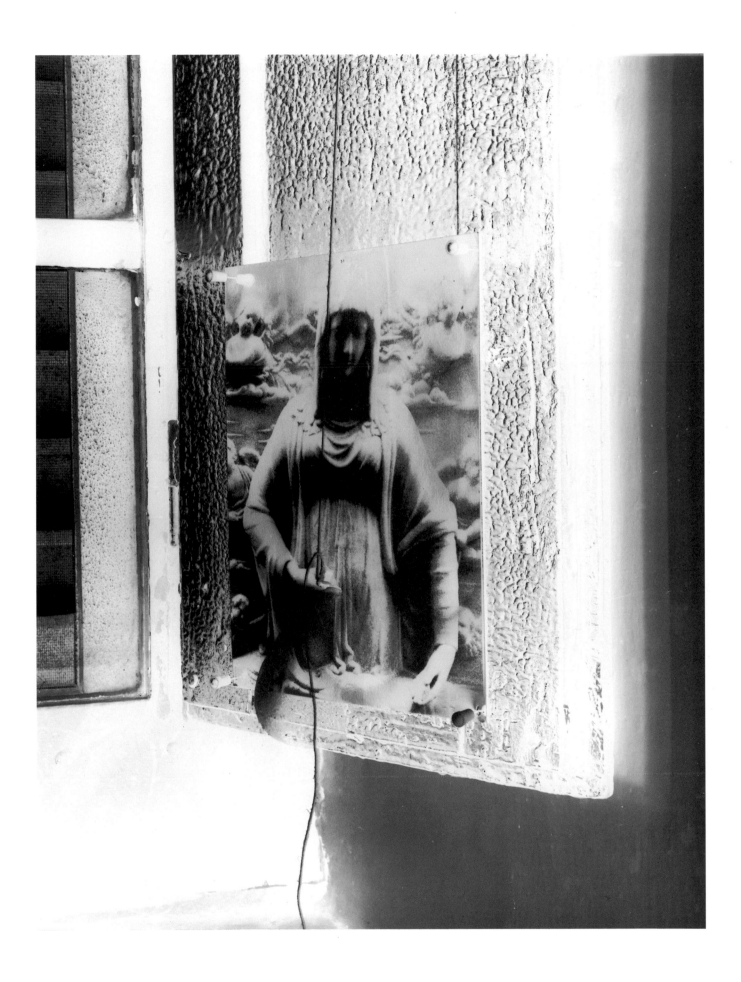

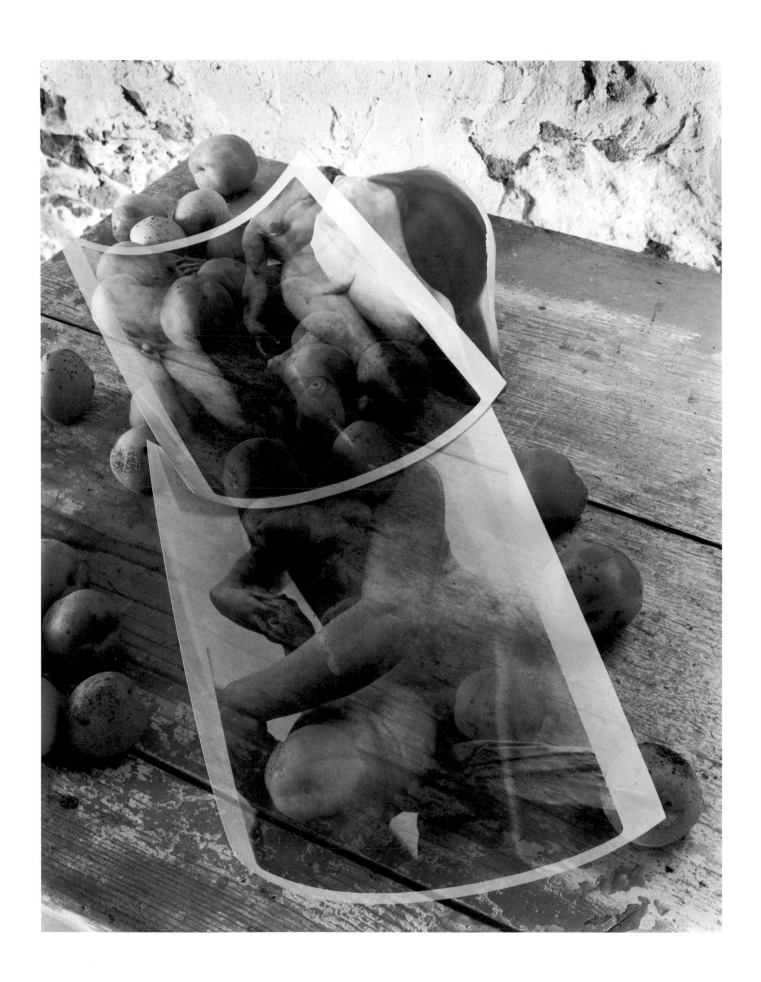

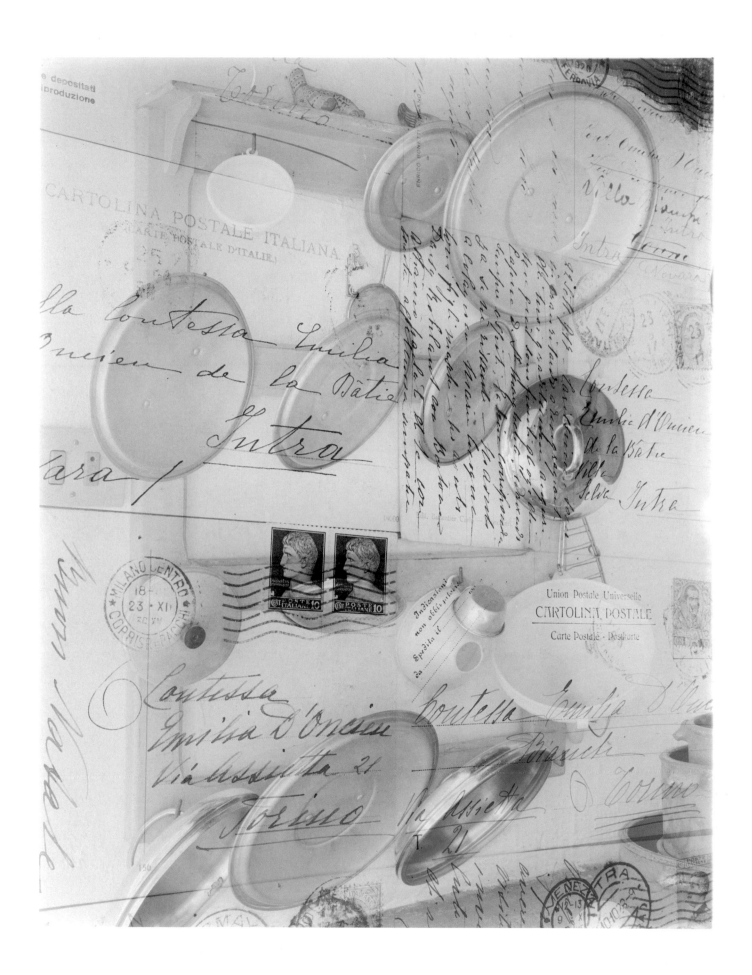

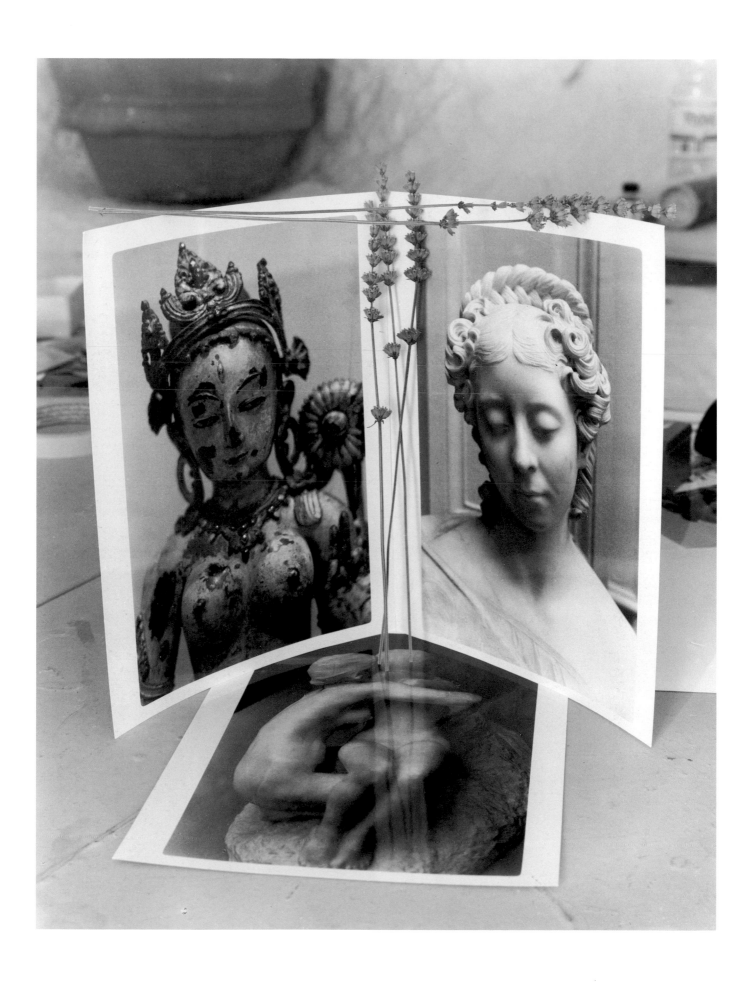

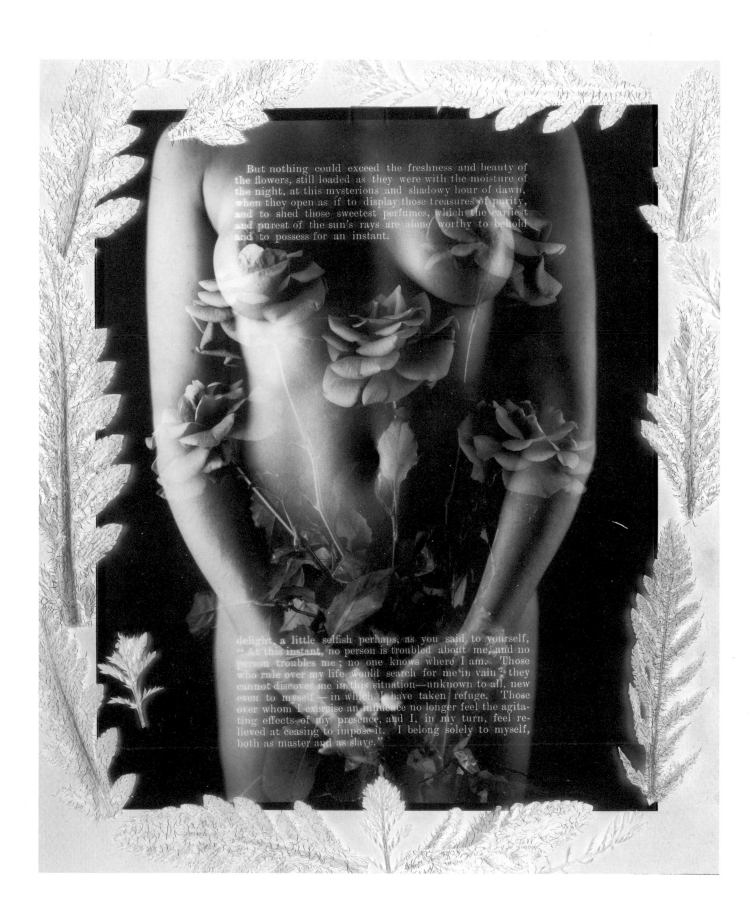

But nothing could exceed the freshness and beauty of
the flowers, still loaded as they were with the moisture of
the night, at this mysterious and shadowy hour of dawn,
when they open as if to display those treasures of purity,
and to shed those sweetest perfumes, which the earliest
and purest of the sun's rays are alone worthy to behold
and to possess for an instant.

delight, a little selfish perhaps, as you said to yourself,
"At this instant, no person is troubled about me, and no
person troubles me; no one knows where I am. Those
who rule over my life would search for me in vain: they
cannot discover me in this situation—unknown to all, new
even to myself—in which I have taken refuge. Those
over whom I exercise an influence no longer feel the agita-
ting effects of my presence, and I, in my turn, feel re-
lieved at ceasing to impose it. I belong solely to myself,
both as master and as slave."

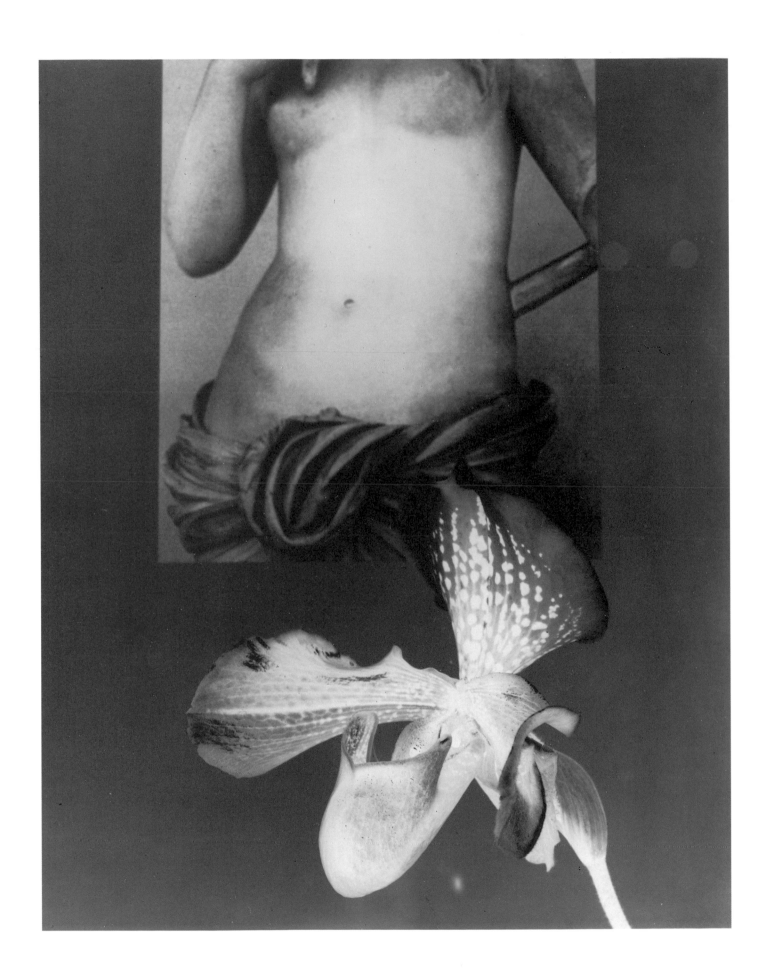

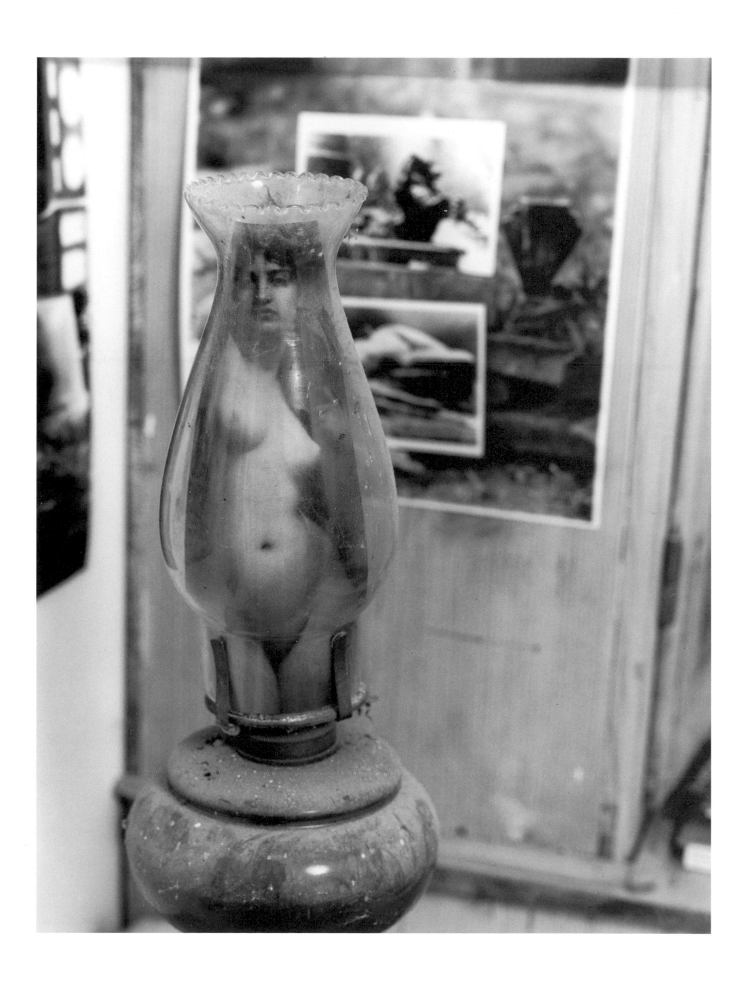

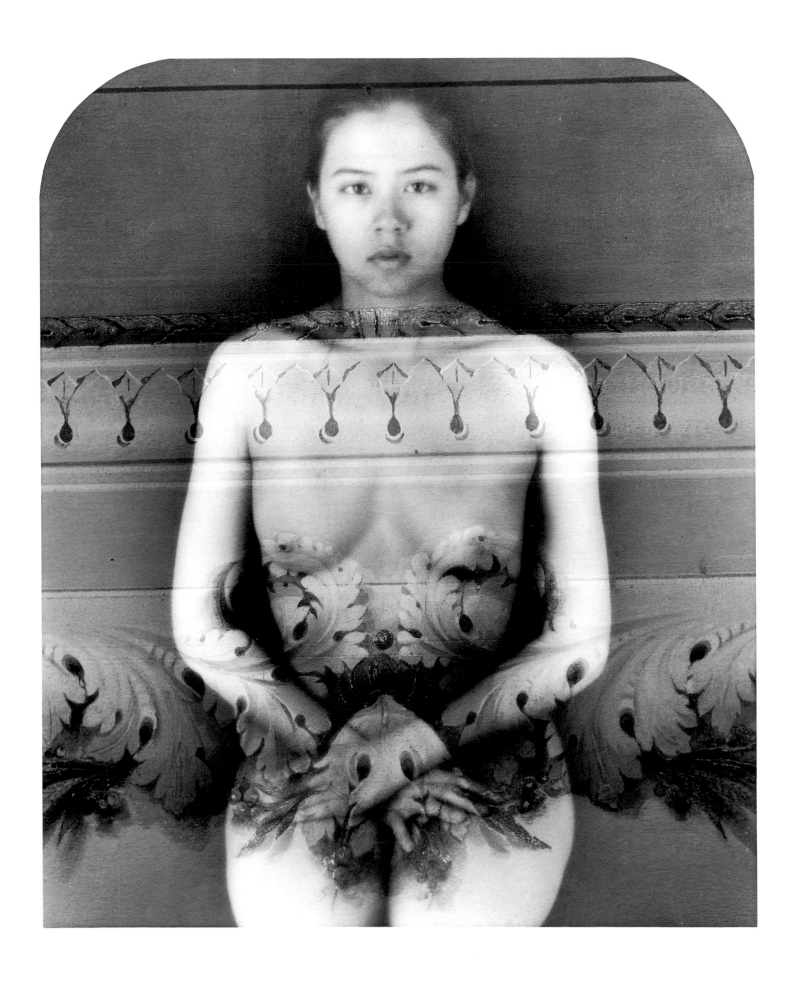

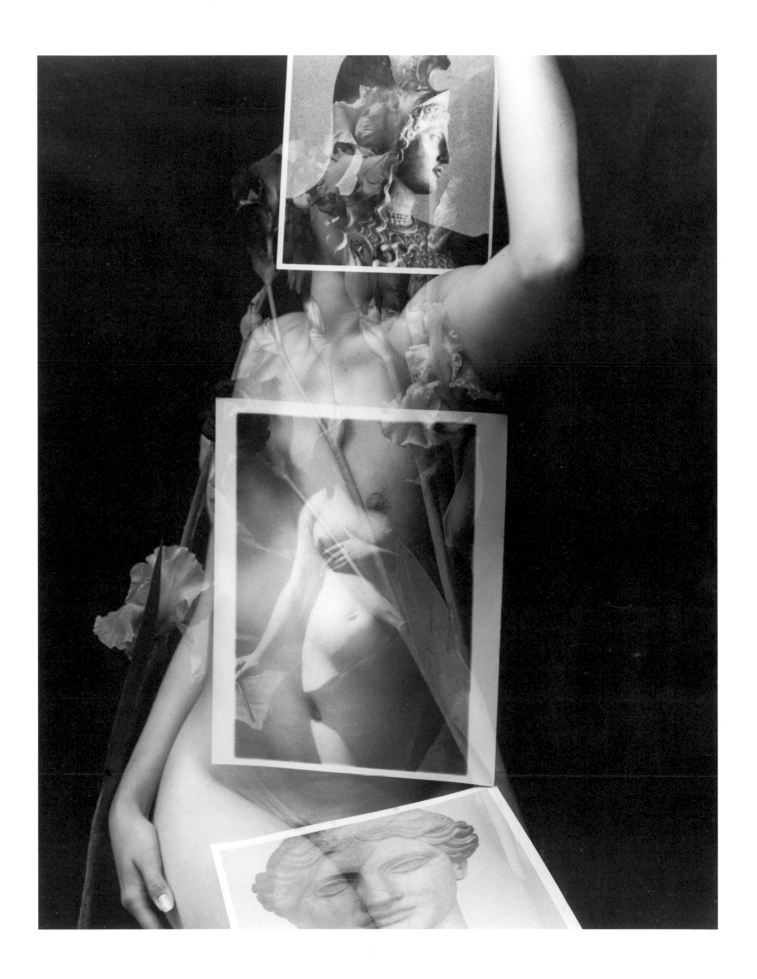

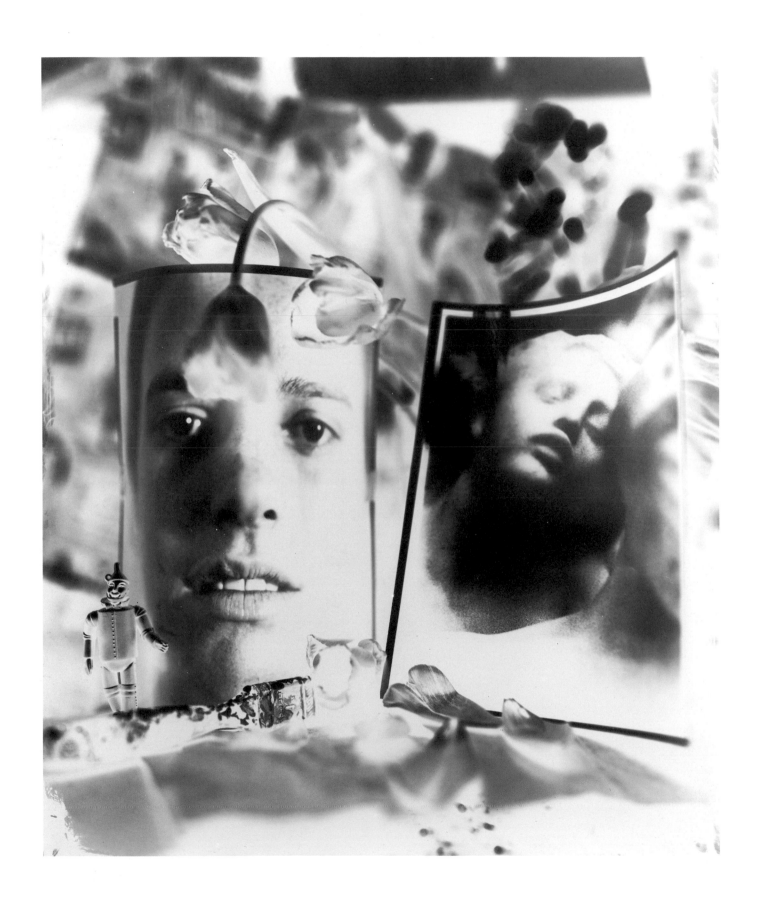

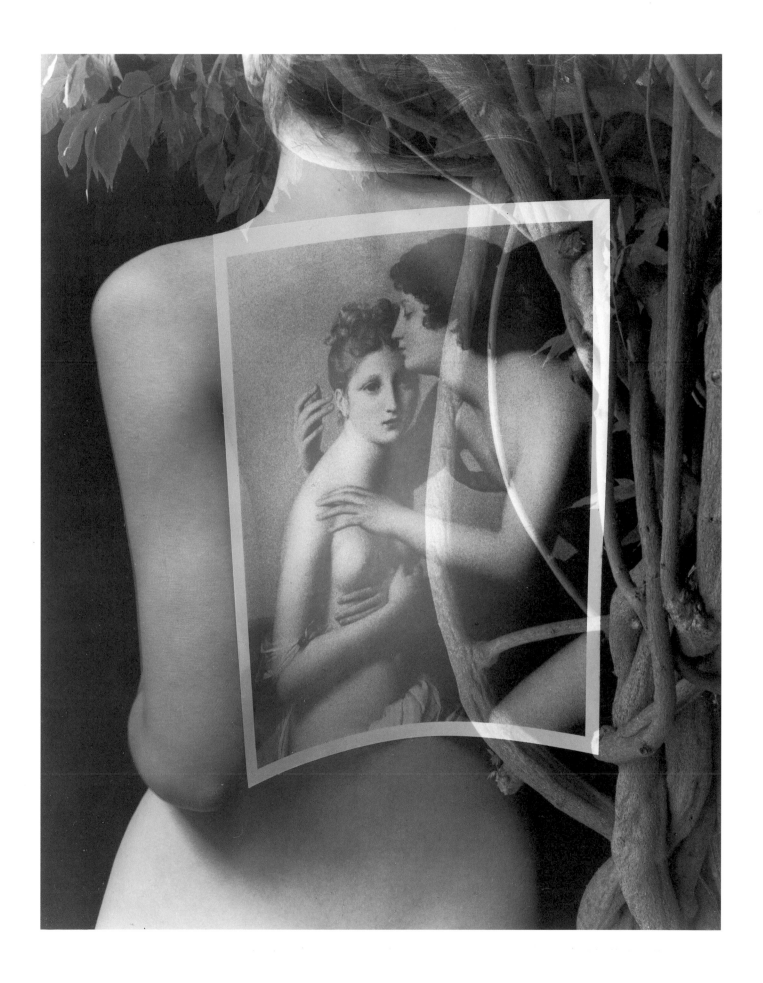

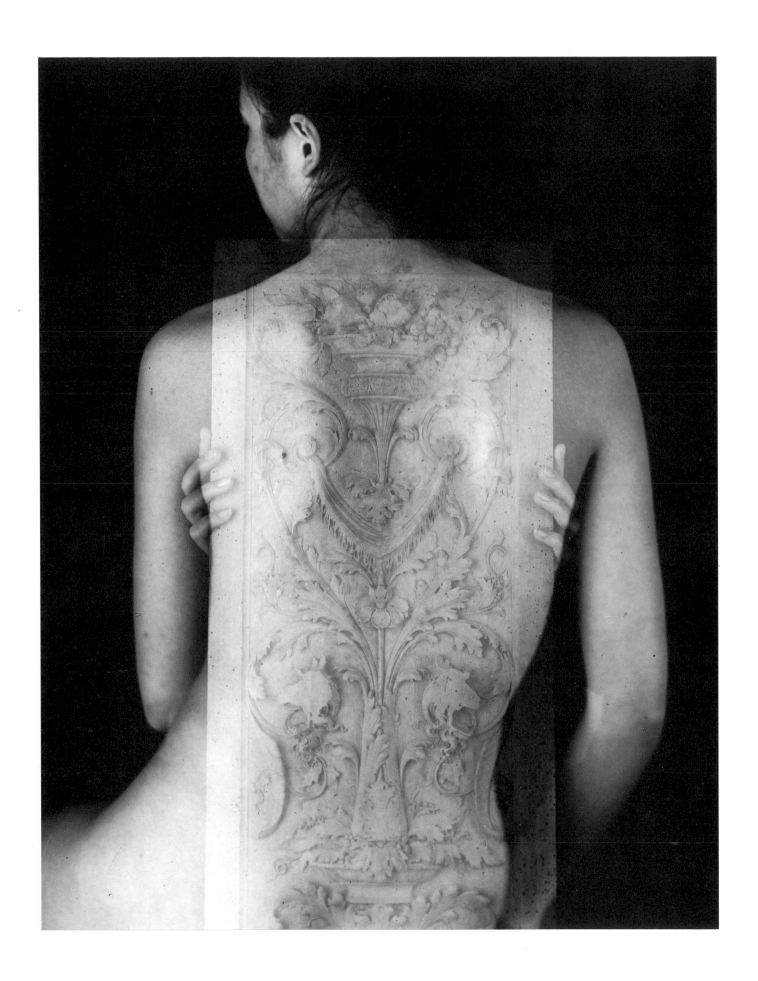

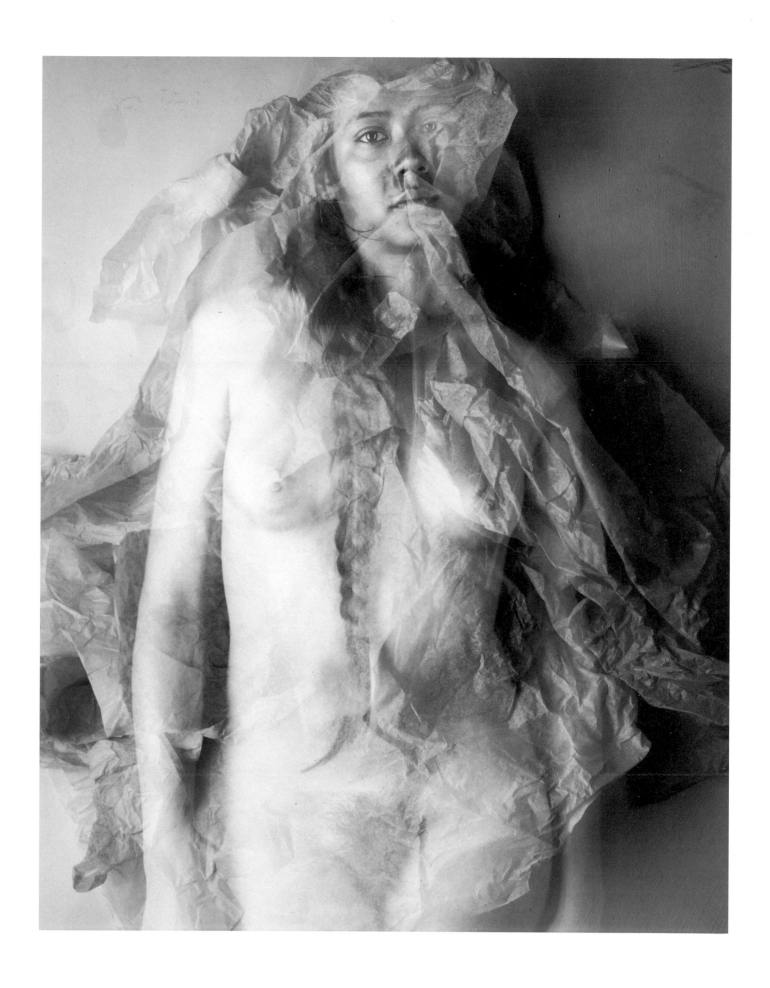

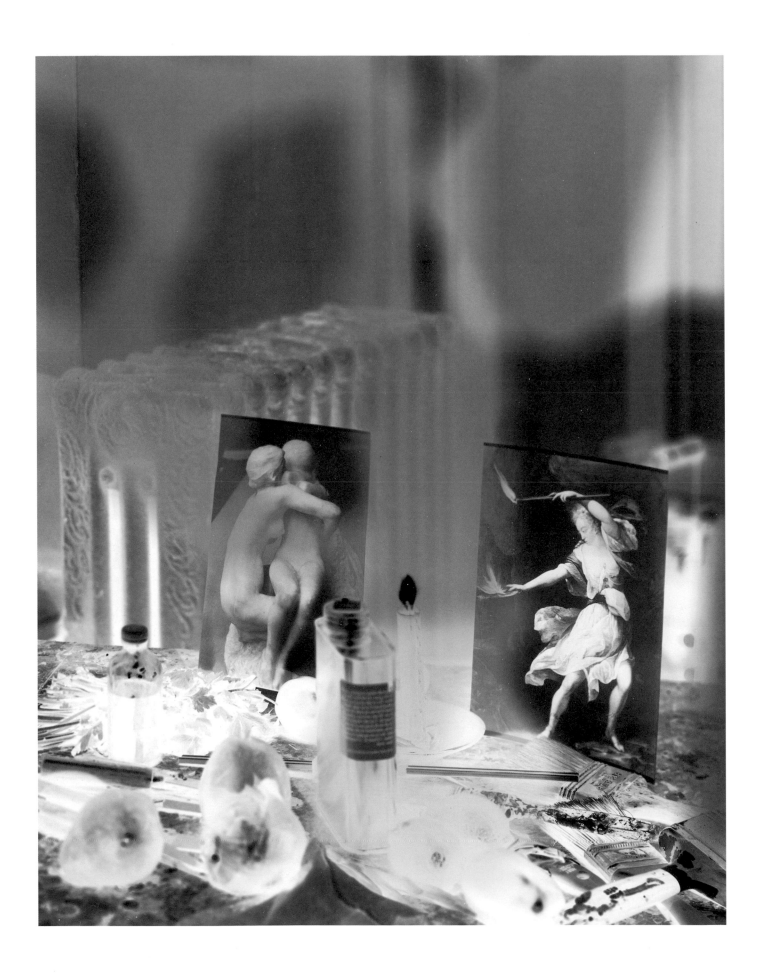

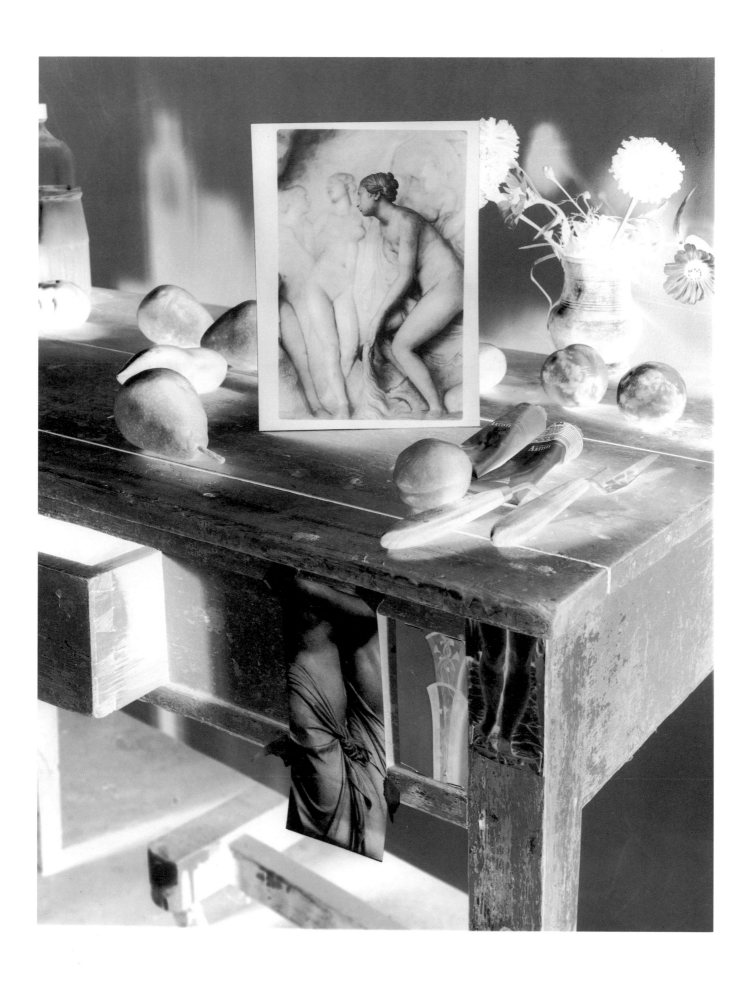

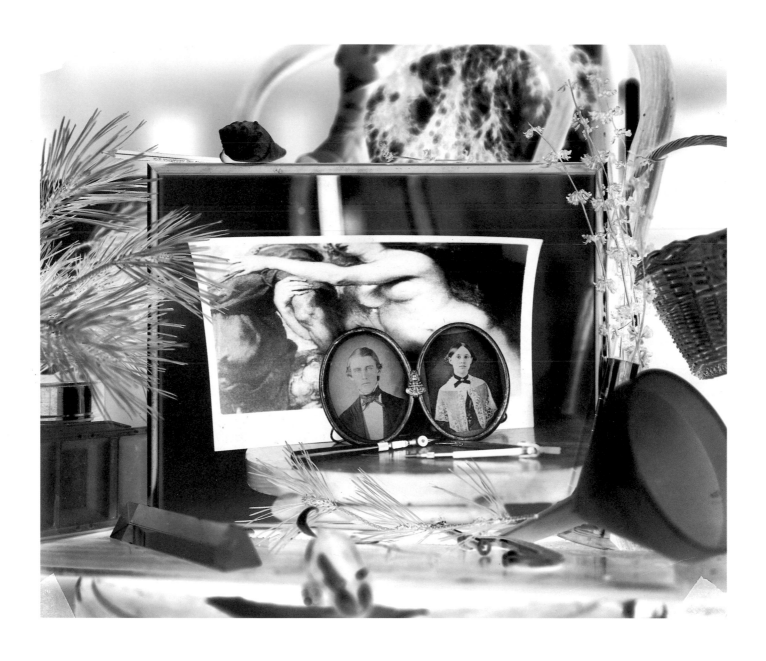

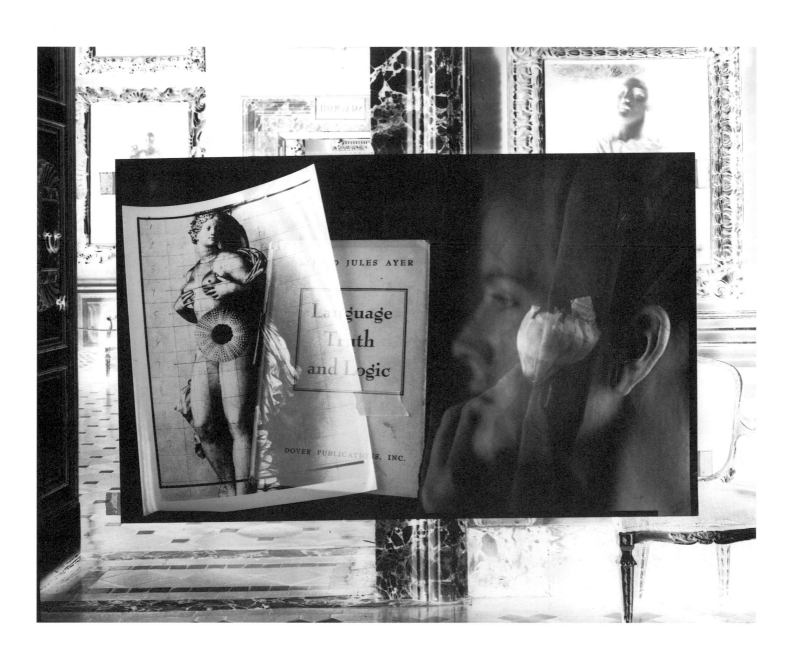

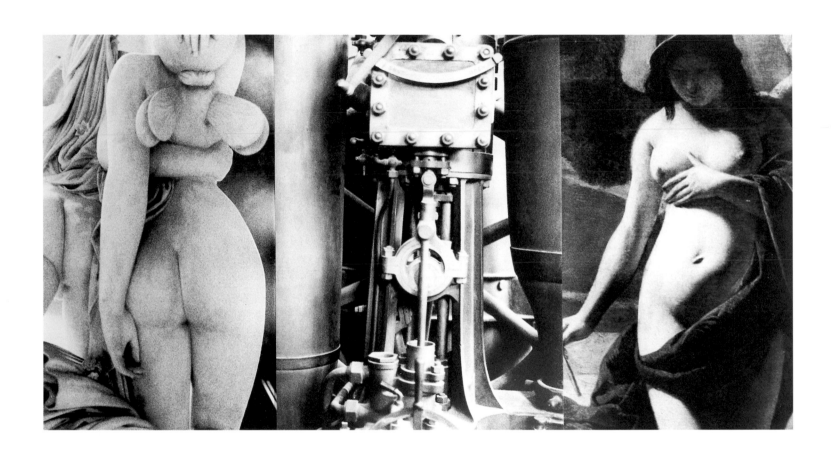

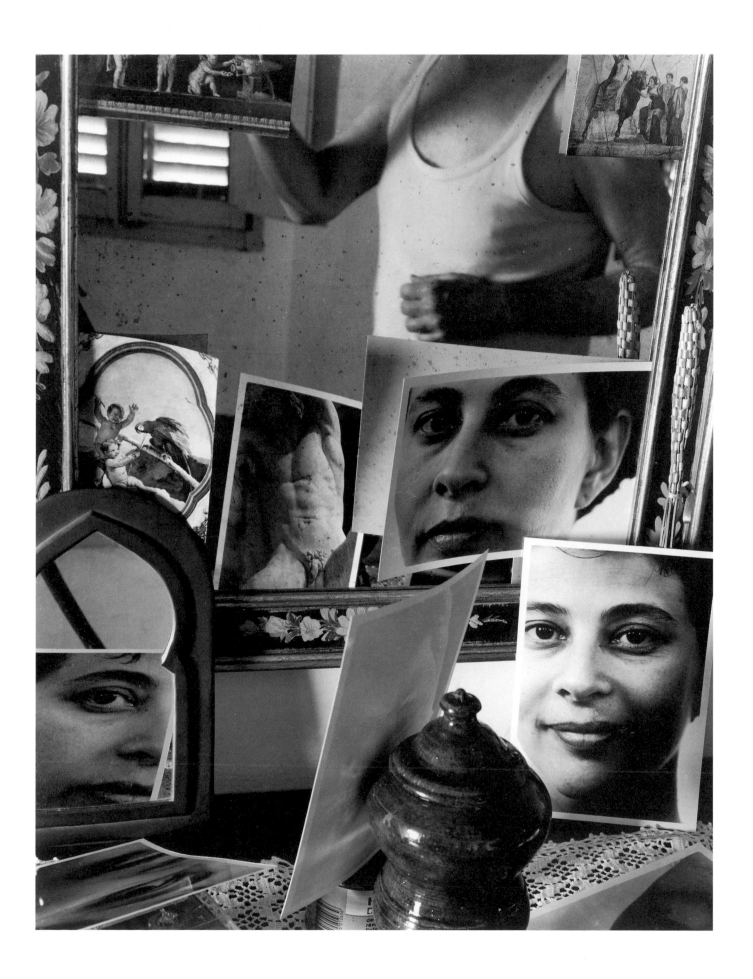

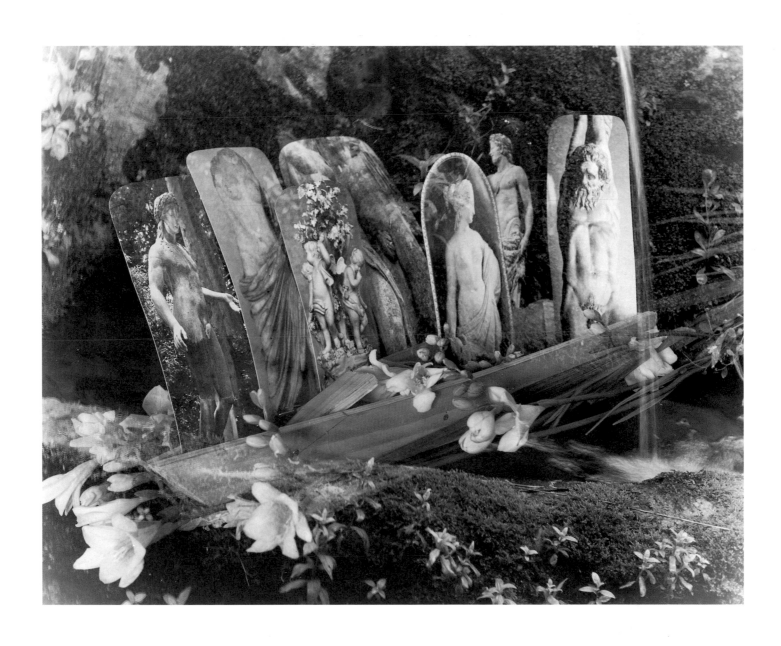

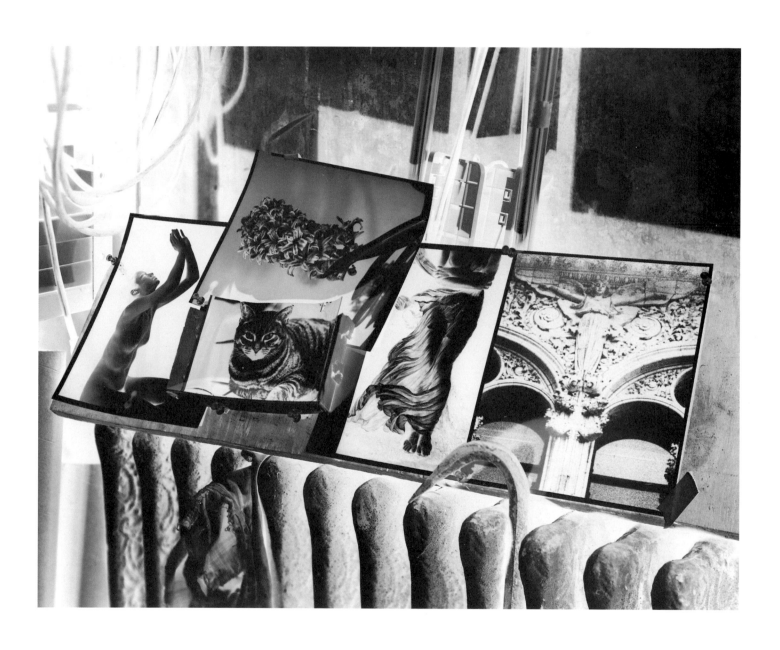

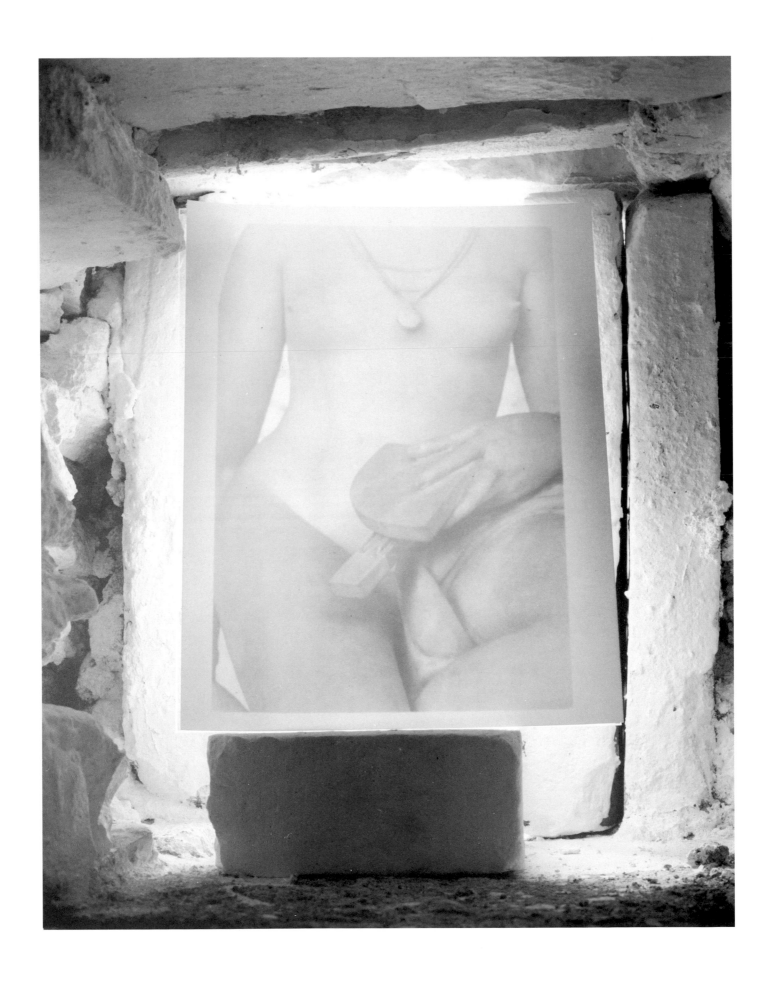

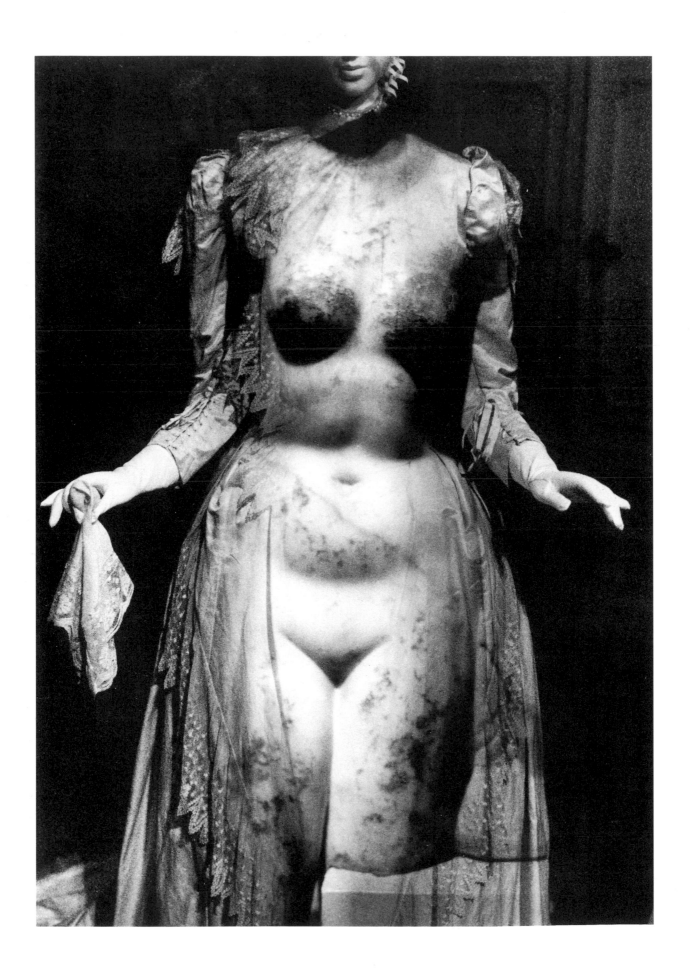

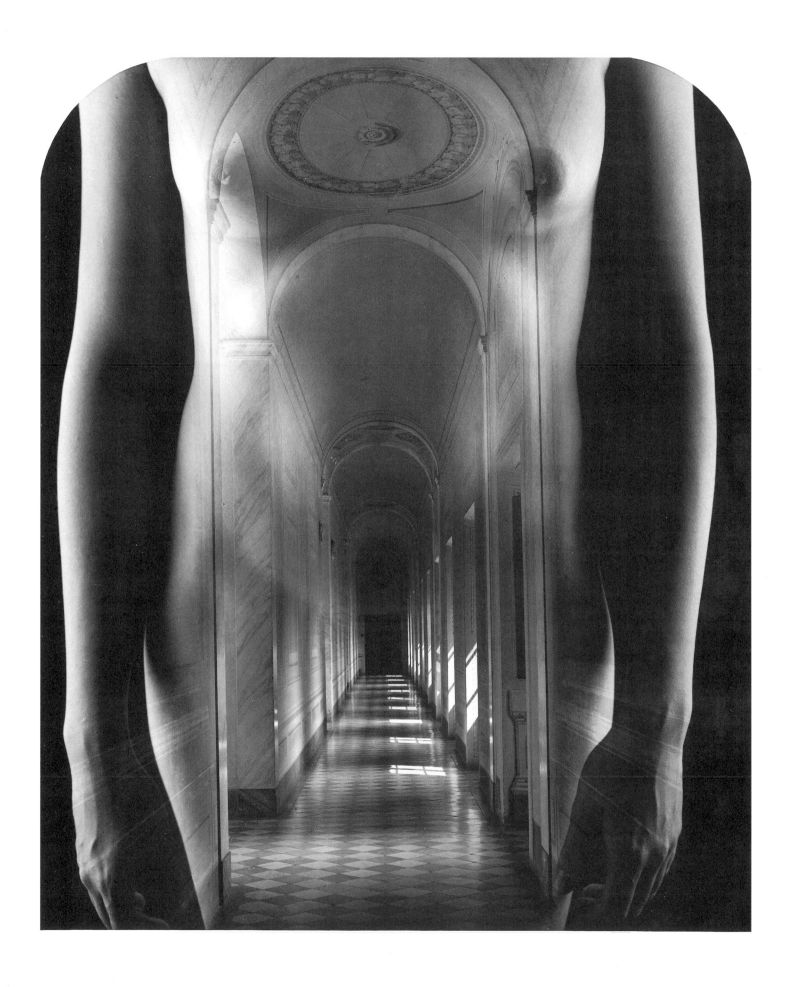

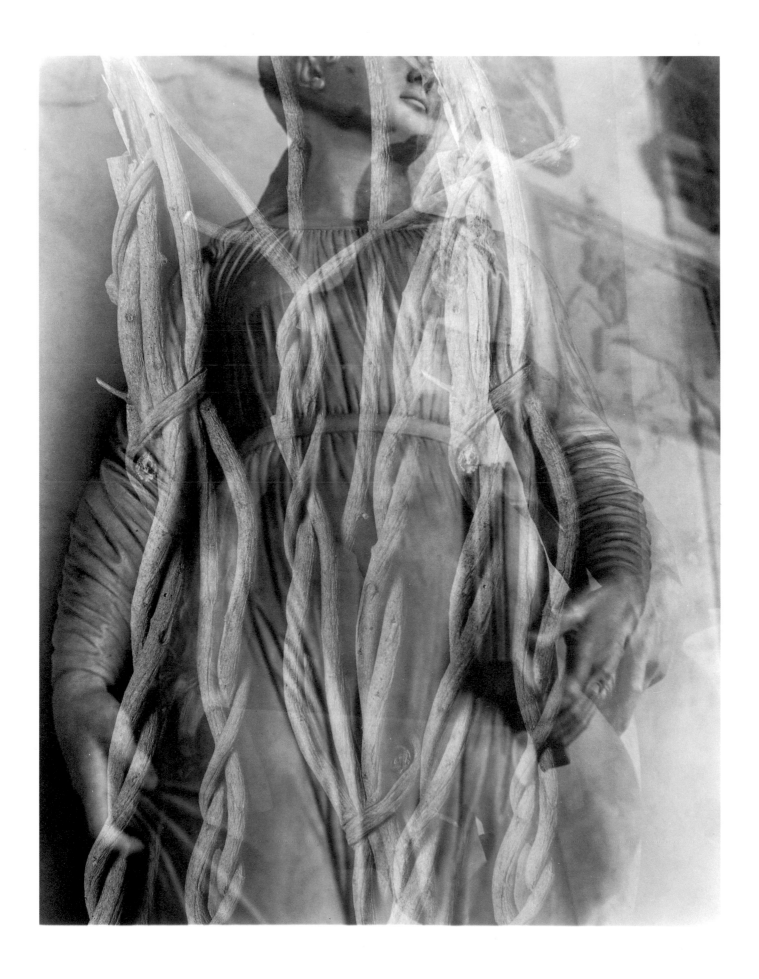

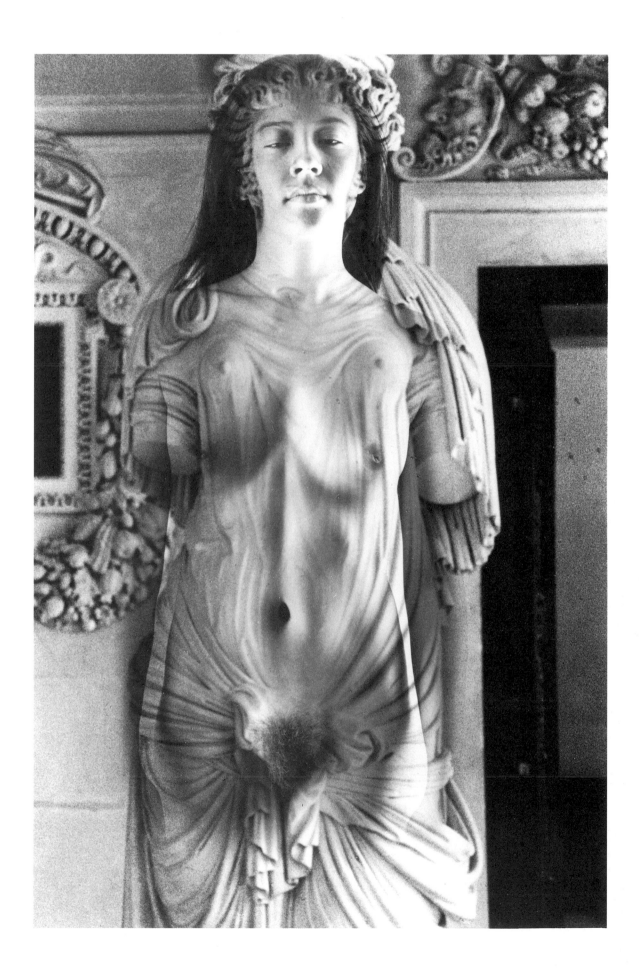

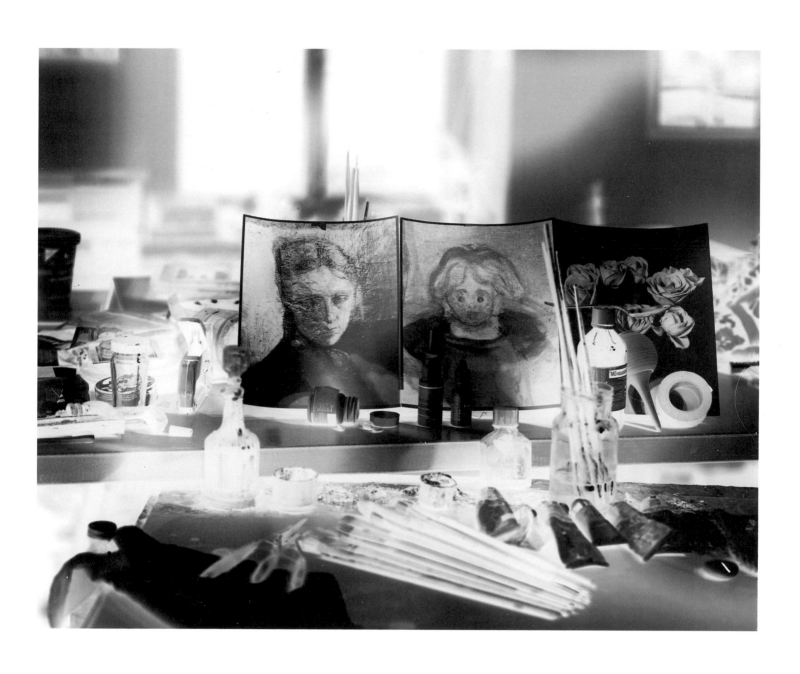

MUSEUM PIECES

The dates and places refer to the year of completion and the artist's studio in Antella, Italy, New York, or Boulder, Colorado where the image finally took form. The works of art in the pictures were previously photographed in the various museums where those objects reside.

George Woodman

NOTES ON SCULPTURE AND PHOTOGRAPHY

W HEN THE CAMERA was invented, the question then arose: "What to photograph?" Obviously, it had to be something interesting, that stands still, and is conveniently at hand. The only things I know that combine the interest of people, the immobility of stones, and an easy availability are casts, figurines and fragments of sculpture. No wonder they appear often in early photography and are soon joined by more monumental and architectural sculpture. Their presence both humanizes the photographic image and aestheticises it, making it pertain to art by bringing into it an object with style, a sculptural style.

The representation of representations is hardly new in art. There are Roman paintings which include painting and sculpture in their subject matter and even further representations within those representations. Significant examples of this process are found in every period of Western art, down to the inclusion of Japanese prints in Manet paintings or the predations of Lichtenstein upon "modern" art as popularized imagery. The efficacy of photography to represent makes the picturing of sculpture particularly interesting because we enter perceptually with such ease into the photo and onto its subject and then so easily through that to what the sculpture represents. The subject of the photograph (the sculpture) and the subject of the sculpture (a person) tend to coalesce into a new entity, not a "sight," but a "seen sight" in which the strands of two different cultures of representation lie across each other, as in looking through air into water, then at the bent stick in the water, then at the pebbles at the bottom of the brook which have no resemblance at all to the pebbles in the dry streambed in the heat of August. This explains why I was drawn to photograph sculpture.

When we look through one representation at another, what do we finally "see"? That ultimately revealed subject, is it Aphrodite, or merely a girl? My pleasure in combining several representations within a single photographic image is to place question marks around the ultimate subject, fictionalize it, and in the process draw our attention back to how it has been represented. In combining pictures of two sculptures, we not only raise doubt about the "subject" of the sculptures, we raise doubt equally about the sculptures themselves. Two levels of fiction emerge. In more recent work I have tended to distance further the subject of the sculpture by making it clear that rather than representing the sculpture, I am picturing a photograph of it as an object within my photograph. In the paradigm of bracketing, the subject is seen in this form:

My photo of (my photo of [a sculpture of <a person.>])

Of great concern to me is the way in which the viewer sees through the layers of "subject" in my photograph. I hope it is some pleasant archeology of styles, traces of narrative, sentiment, and not without some purely visual interst and beauty.

Theoretically, a painting within a photograph should be no different from a sculpture, but in fact it is because the image of painting-as-an-object is so close in character to photography itself that we plunge easily from the surface of the photo, past the painting as an object, to the subject of the painting itself. When I have used paintings in photographs, it has often been necessary to include a fragment of the frame, a reflection from the surface, or a painting of high stylistic identity so that the painting as thing in the photograph is not lost.

Painting creates the world of illusion, whereas sculpture brings illusion into the world. Western painting has aimed at all-embracing illusion, the vast space of landscape, the temporal reality of events, atmosphere, the illusion of immediate experience (as in Monet), the appropriation of all visual phenomena. The ethos of painting has dominated photography, cinema, television. That lust after "virtual reality," is it not explicit in Van Eyck, groped after in Roman painting?

Part of the sadness of sculpture may lie in the painful restriction of creating a substitute reality as opposed to pictured reality. Photographing sculpture has the effect of pictorializing it. For this reason the sculptures at Versailles have a charm in Atget's photographs which they do not have in actuality. Like fashion models, their beauty as pictured makes us forget their exposed homeliness in reality. The vaunted timelessness of sculptures is melancholy. Their awkward posi-

tion fixed neither in reality nor the pictorial places them outside of "modern" sensibility, as in Browning's words,

> *These statues round us, each abrupt, distinct,*
> *The strong in strength, the weak in weakness fixed.*

POSTSCRIPT: THE MUSEUM AND THE WORLD

To photograph sculpture is to work in the museum. Here there is no "decisive moment," no flux of events for the camera to stop. Tomorrow will be the same as today or next month or year. But timeless it is not; the historical pressure is enormous. One feels like a deep-sea diver in time, and the decisive moment in the mind is critical and must be brought to focus. It is a commonplace to regard the museum as opposed to the "real" world; in the eyes of modernism it was an irrelevant mausoleum of culture, for the Futurists an enemy best destroyed. In fact, the museum is as real as rocks, the place where we can see how people have seen and appreciate the style and intelligence with which they saw. It is where the past has its present in the effort of each generation; in T. S. Eliot's terms, to define tradition from the perspective of today. It is in this way that I think of my work as "traditional," sometimes as "museum pieces," taking and giving back as best I can.

George Woodman was born in Concord,
New Hampshire in 1932. He was educated at
Phillips Exter Academy where he studied
painting with Glen Krause. At Harvard he
came under the influence of critic and literary
theorist I. A. Richards, receiving his B. A. with
Honors in Philosophy in 1954. After earning
an M. A. in Fine Arts at the University
of New Mexico, he joined the faculty at the
University of Colorado, Boulder, where
he taught theory of art and painting until his
retirement in 1995. Part of each year since
1966 has been spent working in Italy where
he eventually acquired a farm house outside
of Florence. Since 1978, part of each year
has also been spent in New York. His work
has been concentrated on photography
since the mid-1980's. George Woodman is
married to the ceramic artist Betty Woodman.
Their son, Charles, is a video artist. Their
daughter, Francesca, who died in 1981, was
a photographer.

Woodman's work is represented in the
collections of The Museum of Modern Art,
The Solomon Guggenheim Museum, The
Whitney Museum of American Art, The
Brooklyn Museum, The Houston Museum
of Fine Arts and The Denver Art Museum,
as well as in many private collections.